How To
Photograph
Animals
in the Wild

How To Photograph
Animals in the Wild

Dr. Leonard Lee Rue III
Len Rue, Jr.

STACKPOLE
BOOKS

Published by
STACKPOLE BOOKS
5067 Ritter Road
Mechanicsburg, PA 17055

Printed in Hong Kong

10 9 8 7 6 5 4 3 2 1

First edition

Cover design by Tracy A. Patterson with Kathleen D. Peters

Library of Congress Cataloging-in-Publication Data

Rue, Leonard Lee.
 How to photograph animals in the wild / Leonard Lee Rue III,
Len Rue, Jr.—1st ed.
 p. cm.
 Includes bibliographical references.
 ISBN 0-8117-2451-4 (pbk.)
 1. Wildlife photography. 2. Photography of animals.
3. Nature photography. I. Rue, Len. II. Title.
TR729.W54R84 1996
778.9'32—dc20 95-31022
 CIP

To my darling wife, Uschi
Who has enriched my life with her love
and enhanced my work with her help.

L. L. R. III

To my parents,
Leonard Lee Rue III and Beth Rue-Mease,
my wife, Joan,
and my sons, Nicholas and Adam,
who are two of the best sons
any father could ever hope to have.

L.R., Jr.

CONTENTS

INTRODUCTION

Leonard Lee Rue III

The most basic ingredient for success in animal photography is knowing and understanding animals. I was the first one in my family to be interested in wildlife of all kinds, and I was fortunate to move to a mountaintop farm when I was nine. I have been surrounded by and lived with wildlife ever since. From the age of eleven on, I hunted and trapped and roamed the woods and fields. I was on the river every moment I could spare—and some that I could not. To be successful in either hunting or trapping, one must know what kind of wildlife lives where, and why and when it will be there. I had to know what it ate, when it mated, and at what times of the day it did both of these. These are also the basic requirements for being a successful wildlife photographer. Although I photograph everything in the realm of nature, I am first and foremost, by preference, an animal photographer.

My son, Len Rue, Jr. (that's his professional name; he is actually Leonard Lee Rue IV), has been exposed to wildlife all over the country all his life. Other kids grew up raising puppies. We did that too, but we also raised raccoons, opossums, foxes, and deer, among others. I had him down to the Everglades when he was eight, up in Canada when he was nine, out to Yellowstone when he was twelve. We photographed brown bears on the McNeil River and grizzlies in Denali, Alaska, when he was seventeen. Since then we have been to Australia, South America, and Africa and have worked across North America countless times.

Len is a better technical photographer than I will ever be. I've never been interested in the mechanics of cameras, lenses, or film. Len has a degree in photography from Rochester Institute of Technology. My love has always been, and remains, the creatures themselves.

How do you go about learning about animals? Nothing will ever take the place of being out in the fields and woods and learning firsthand, but reading this book will get you started. Join your local camera club or bird club, go out with members of your local hunting club, talk to your state fish and game biologists and wardens, talk to anyone who spends a lot of time in the out-of-doors. Take advantage of their years of knowledge; they will be glad to share it with you.

The Subjects

Finding Wildlife

Leonard Lee Rue III

Most folks are amazed to learn that I live in New Jersey. Many of them know New Jersey only as a megalopolis. But I live in the mountainous northwest corner of the state, and my home backs up against the Blue Ridge section of New Jersey's Kittatinny Mountains. We have about thirty deer per square mile, and hundreds of black bears roam the mountains behind my home. We have foxes, coyotes, skunks, opossums, mink, otters, muskrat, beavers, woodchucks, tree squirrels, chipmunks, and on and on, a veritable Noah's ark.

What I'm trying to say is that, unless you live in the city, you probably have great opportunities for photographs right in your own backyard, Just about the only place you can't photograph wildlife is where it is hunted. And even if you do live in the city, every park has its share of squirrels, which make great photographic subjects. New York City's Central Park is one of the best spots in the entire country to photograph gray squirrels. By shooting up from a low angle, you can even eliminate the skyscrapers in the background. Many cities also have green beltways around or through them. Such areas usually abound with deer, squirrels, rabbits, and other wildlife. Suburban areas are even better, because there are usually more protected open areas. They may lie adjacent to farmland or rural areas, which provide almost unlimited food sources for many kinds of wildlife.

Many suburbanites put out food for the wild creatures just because they like seeing them. Such wildlife becomes accustomed to people and will allow you to approach more closely. Never forget that you are dealing with wildlife, however, and that it should be respected as such. Los Angeles had to pass a law several years ago against feeding the coyotes that were coming into the backyards after several small children were attacked. Wild animals that have lost their fear of people are more dangerous than the wildest of wild animals. The most dangerous wild animal in North America today is a white-tailed buck that has been raised in captivity and was bottle-fed as a fawn. That buck has no fear of humans and, during the rutting season, he is a living time bomb.

We are truly blessed here in the United States in that we live in such a magnificent country that embraces every conceivable type of habitat. We have over 650 species of birds, 375 species of mammals, more than 200 species of reptiles and amphibians, and countless species of insects.

There are presently 358 national parts in the United States, with a total of over 80 million acres, and new parks are being added.

Not all our national parks are wildlife parks, but most of them are. More wildlife photographs are taken in national parks than in all other areas combined. Although most of the 300 million yearly visitors to these parks are photographing as tourists or amateurs, the professional wildlife photographers are there too, because that's where most of the wildlife is. I have photographed wildlife on all seven continents, and my favorite spot in the entire world is still Yellowstone National Park.

Wildlife in the national parks is given complete protection and is exposed to large numbers of people. This combination allows most of the creatures to become used to humans and thus offers the greatest photographic opportunities. Because of each species' individual habits, certain times are best to be in the various parks to record peak animal activities. For example, the birthing time for deer, elk, pronghorn, moose, and bison in Yellowstone is late May or early June. The breeding season for bison is August to September; for elk, moose, and pronghorn it is from September 15 to October 15; and for bighorn sheep and deer it is the first part of December. It is during the breeding season that all male animals are at their best. They are in the best flesh; the antlers of the deer, elk, and moose will have shed the velvet and will be polished, strong, and sharp. The testosterone levels of the male animals are at their highest during breeding season, and animal activity is at its peak as each male tries to attract and keep the largest number of females possible in his harem. There will be territory marking, chases, bluffing, herding, fighting, and breeding activity, all of which make for exciting photographs. The high testosterone levels also make the males more dangerous to photograph, as elk, moose, and bison bulls are more than willing to take on rival bulls, humans, and sometimes even machines. In an average year, fifteen people are gored by bison in Yellowstone National Park. Do not attempt to photograph any of these belligerent animals during the rutting season with anything less than a 400mm lens.

There are more than 475 national wildlife refuges in the United States, encompassing over 91 million acres, and every state has at least one. The national refuges also offer unequaled wildlife photographic opportunities, but some of the wildlife is more wary there than in the national parks, because some hunting is allowed in outlying parts of most refuges. Many of the refuges were created specifically for migratory or resident waterfowl, but all of them are home to many animal species.

State parks, county parks, and community parks are all good places for wildlife photography. The large tracts of land surrounding reservoirs, power plants, industrial plants, hospital grounds, Scout and YMCA or YWCA camps, and nature centers usually provide complete protection for all wildlife and are equally productive for photography. For example, the CIBA-GEIGY Toms River plant in New Jersey has 1,600 acres, 1,100 of which have been put aside for wildlife. I was so impressed with the wealth of wildlife there that I did a videotape of the wildlife for the company to use as a public-relations tool; it is a good steward of the land.

Do not overlook campgrounds and picnic areas; wherever people are eating, there will be wildlife waiting to be fed. Although there are regulations against feeding the wildlife, it's almost certain that somebody will; it's human nature. It's also animals' nature to get food in the easiest manner possible. Don't photograph the animals with the food or when they are in the picnic area. Photograph them coming out of the natural surroundings outside the picnic area.

Zoos offer limited opportunities for wildlife photographs. If the photos are just for your own pleasure, then having bars or con-

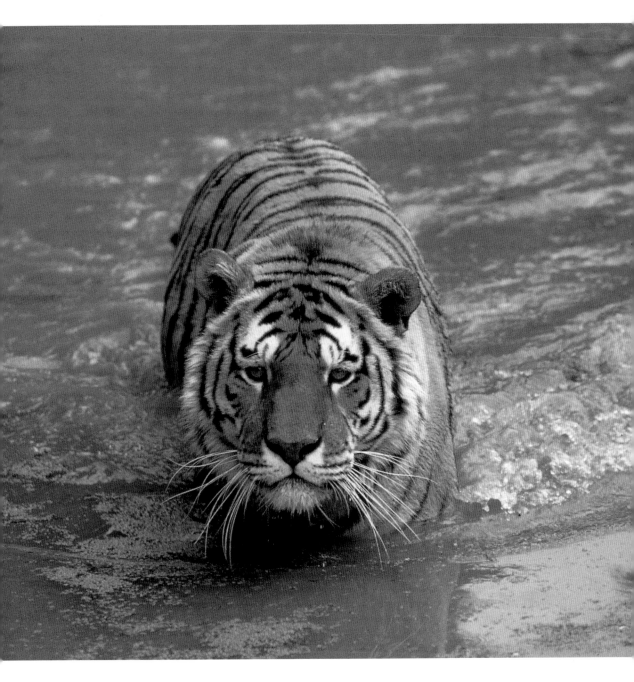

200–400mm zoom lens, Kodachrome 64 film, 1/250 sec., f/5.6.
Many of our zoos now keep their animals in natural enclosures; with careful set up, this zoo
tiger appears to have been photographed in the wild. Often, magazines ask (and state) whether
the animal was in captivity when the photo was taken. LEN RUE, JR.

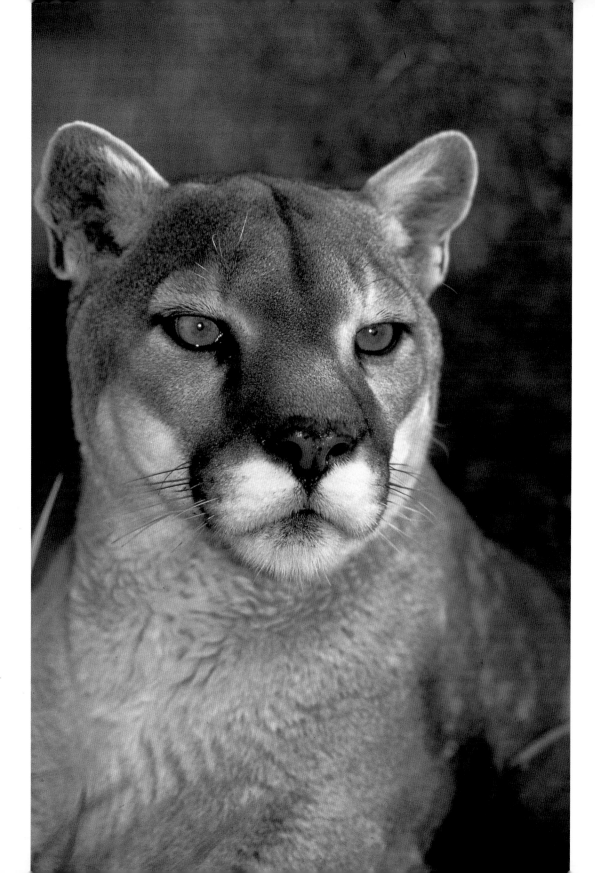

crete walls in the pictures may not make any difference. But if you hope to sell your photographs, you will have to take your photos from a very low angle, or a very high one, to eliminate the bars and backgrounds. Using your largest telephoto lens allows you to get close-ups of the animal's head and thus eliminate the background. Shoot at the highest shutter speed possible. This, coupled with the inherent shallow depth of field of all true telephoto lenses, will eliminate most distracting backgrounds. Shooting your subject as it stands in front of a shadow-darkened wall will also eliminate the background. Most of the larger zoos are now housing their animals in large, natural-habitat holding areas, so you may not even have a problem with the background. Don't go to zoos on holidays or weekends, when the crowds are the largest, as your tripod will block traffic. Be at the zoo when it opens, because as soon as the day warms up, most animals seek out the shade and sleep for the day. Ask when the feeding times are—usually late afternoon—because the extra activity may offer good photographic opportunities.

Inquire about animal rehabilitation centers in your area. You may be able to photograph some of the animals there. Even animals with injured feet or legs offer good close-up head portraits if you use your macro lenses.

Today, more and more people, both amateur and professional, are relying on rented animals to fill out their files of species. Whenever you see photographs of bobcats, lynx, cougars, and most wolves, in 99 percent of the cases, the photographer went to

200–400mm zoom lens with 1.4 teleconverter, Kodachrome 64 film, 1/125 sec., f/5.6.
Most photos of bobcats, lynx, and cougars are taken on game farms. LEN RUE, JR.

the local Rent-a-Cougar farm. The cost for a day's shooting—two hours in the morning and two hours in the afternoon—runs about $300 to $350 for one major species (any of the above) and one lesser species, such as a fox or raccoon. Amateurs may not want to do this, and that's understandable. But anyone who hopes to make it professionally has to do this in order to be competitive.

Photo opportunities abound in most areas if you just take the time and make the effort to get out there and look for them.

Understanding Wildlife
Leonard Lee Rue III

Flight or Fight
All of us have been excited about the prospect of photographing some animal in our backyard or in a national park, only to be disappointed when it runs off before we get the photo. That is the animal's basic instinct for survival. Except for a brief period during the peak of the breeding, or rutting, season, survival takes precedence over everything else. That precedence requires that we understand the "flight or fight" principle.

Flight. An animal, depending on its type, size, speed, strength, and closeness to safety, allows a human to approach just so far and then flees. This is why most wildlife photography is done in protected areas such as national parks. Animals that have become used to being around humans may ignore you completely or even approach you. Those that have not will run off to escape what they consider to be a potential danger—you. That's the flight part of the principle.

As you work with wildlife, you will become more attuned to their behavior and their reactions; you will be able to recognize their intent to flee by their body positions—body language, if you will. There are

things that you can do to reassure the creatures and so approach them more closely. Here's what I do: I never approach an animal directly if I can do so by a circuitous route. As I approach, I try to come in so that the sun is in a favorable position. I shoot against the light sometimes, but the majority of your photographs should be taken with the sun somewhere behind you. I don't hurry; I move slowly, angling ever closer to the animal and trying for favorable light. I don't look at the animal; I avoid all eye contact. I pretend that I don't see the animal or that I am not interested in it. This is hard to do, but a studied indifference can be developed.

In Africa, I have seen zebras, wildebeests, and other game species watch a lion that has just fed walk through their midst. The lion's very posture, its behavior, announces the fact that it is not interested in any of the animals. A hunting lion's demeanor is tense, alert; it carries its head and ears in a different position, which alarms other animals, and they move away.

I have found that I can usually approach a creature much more closely when I am not carrying a camera. But it's not the camera that makes the difference; it's the fact that, when I'm not carrying a camera, I have the more relaxed attitude of a well-fed lion. When I plan to take photographs, I am alert; I represent the hunter, and it makes no difference whether I have a camera or a gun. The animals recognize me as a hunter and are instantly more wary. To counteract this, you have to develop a relaxed, I-don't-care attitude. The more successfully you can exhibit this attitude, the more successful you will be in wildlife photography.

Len and I were trying to photograph a band of Dall's ewes and lambs in Alaska. The sheep spotted us soon after we spotted them. Once an animal has spotted you, you must stay in its view. If you drop into a ravine or try to hide behind intervening vegetation, the animal will instantly define you as a predator that is attempting to sneak closer. When you reemerge, your quarry will probably be gone. So as we moved closer, we took great pains to stay in the sight of the sheep. We got to within 200 feet before the sheep showed any signs of uneasiness by stopping their feeding and staring at us intently. Still in plain sight, Len and I took off our packs, set down our tripods, sat down, and began to eat our lunch, S-L-O-W-L-Y. The sheep relaxed, began to feed, gave in to their curiosity, and gradually fed in our direction. They eventually came to within 50 feet or so, allowing us to get all the photos we desired. The lesson is, don't hurry wildlife.

Another thing I do is talk to wildlife. I was raised on a farm, and you soon learn not to startle the critters you are tending. I almost got myself killed when I walked up behind one of our horses without talking to him. The horse had his head down in the manger and didn't know I was there until I was behind him. His survival instinct caused him to kick out with both hind feet, hitting me in the chest.

I have found that talking to animals lets them know that you are a human, lets them know exactly where you are, and lets them know that you aren't stalking them, because predators are always silent. The human voice has a tendency to reassure wildlife, to calm it down. It doesn't matter what you say, as long as you say it in a quiet monotone.

Fight. The fight part of the principle comes into play if you get so close to an ani-

55mm macro lens, Kodachrome 64 film, 1/250 sec., f/9.
This Dall's sheep ewe showed its acceptance of Len Rue Jr. by bedding down while he took this photograph. LEONARD LEE RUE III

mal that it feels cornered. Animals out in the wide-open spaces consider themselves cornered if they feel that you could catch them before they could get away. I have had muskrat, woodchucks, and a badger charge at me because they felt that they couldn't get to the water or to their burrows safely. Being chased by a muskrat was an affront to my dignity, and my jumping backward was most undignified, but no one saw me do it. The point is, I didn't expect it, and that was a mistake. Working with wildlife, you should always expect the unexpected.

Although most animals of the same species usually do the same thing in response to the same situation, animals are as individualistic as we are, and that must be taken into account. Although people are occasionally injured by wildlife, it's a lot safer being with wildlife than it is driving your car to go photograph the wildlife. It is unfortunate so many television shows and movies depict wildlife as being cute and cuddly. They are neither. They are wild animals that must be treated with great respect.

Do not even think about photographing big-game animals with any lens shorter than 400mm, preferably with a 1.4 teleconverter. With this lens, you can stay 150 feet from an elk or moose and still fill the frame with your subject. Most parks require that you stay 150 feet from big hoofed animals and farther than that from bears. At that distance, the animals don't consider you a threat, and if they do act aggressively, you have three seconds to get out of the way.

Whenever I am photographing a potentially dangerous animal, I always devise a plan of action in advance. I make sure that I'm aware of the nearest protective cover. If an animal becomes aggressive, there is no time to plan, and very little time for action. Elk, moose, bison, and bears are all capable of charging at speeds of 30 to 35 mph. This means that they can cover between 44 and 51 feet per second—hence the three seconds you have to act. Your best bet is avoidance. Don't approach big animals too closely, and use a big lens.

Years ago, before my first trip to the McNeil River in Alaska in 1966 to photograph the big coastal brown bears, Dr. Troutman, a research biologist who had worked among the bears for years, advised me to carry a police whistle. He claimed that a sharp blast on the whistle could deter a bear from charging. I began carrying just such a whistle in 1949, when I ran canoe trips up into the Canadian wilderness, and I still do. I have used the whistle to turn a charging cow moose. Today I also carry a can of Counter Assault red-pepper bear spray. I know three people who have stopped bears with it, and I have used it successfully on two aggressive captive whitetailed bucks. I strongly recommend that all photographers carry such protection.

Body Language. No animal wants to fight, but usually the males want to be dominant. The larger the bull or the buck, the more dominant he will be over other animals of the same species. Usually the dominant animal signifies his position to lesser males by giving them "threat" gestures—the "hard stare." Unless the rival is of about equal size, he will turn aside because he has been warned by the bigger animal's body lan-

55mm macro lens, Kodachrome 64 film, 1/125 sec., f/11.
The bull moose was photographed from a distance of about 150 feet. Note the tourist who has turned his back on the bull. LEONARD LEE RUE III

200–400mm lens with 1.4 teleconverter, Kodachrome 64 film, 1/125 sec., f/8.
This frame-filling shot of the same bull moose was taken from the same location, but with different equipment. LEONARD LEE RUE III

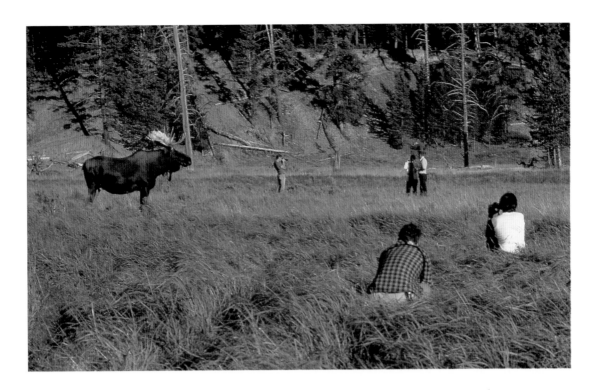

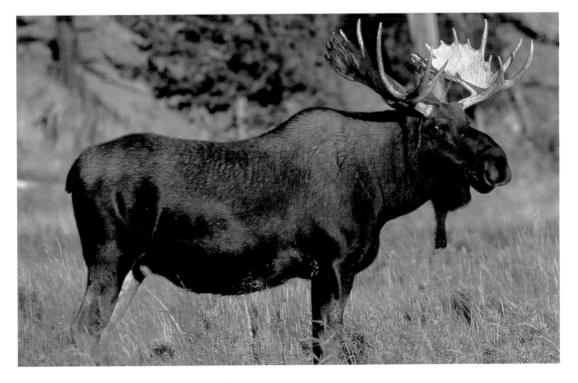

guage. These animals use the same gestures with humans. By knowing their "language," you can save yourself a lot of trouble and perhaps serious injury.

I have never known of anyone being charged by a pronghorn or a caribou. Since both these animals are usually encountered in wide-open spaces, they simply run off when you get close.

Captive deer can be extremely dangerous during the rutting season. The signs of aggression usually occur all at once. The buck lays his ears back along his neck, projects his antlers forward, and erects all the hair on his body. That's the time to be gone. Then the buck usually paws the ground. When he advances, it is done with a stiff-legged gait in a sidling fashion. He may be flicking his tongue out of his mouth and up over his nose. With these last three signs, a charge is imminent. If you started moving when you saw the first signs, you should see the next three signs from safety. If you didn't, you are too late. Each year, some folks are attacked by wild deer; occasionally, someone is killed, but this is a rarity. Any wild deer that exhibits the signs just described is dangerous; climb a tree or seek shelter, but move.

I know of no one who has been attacked by any of the wild sheep, but I have been challenged. A friend of mine had to jump off the trail because a bighorn ram wanted the right-of-way. These types of incidents are

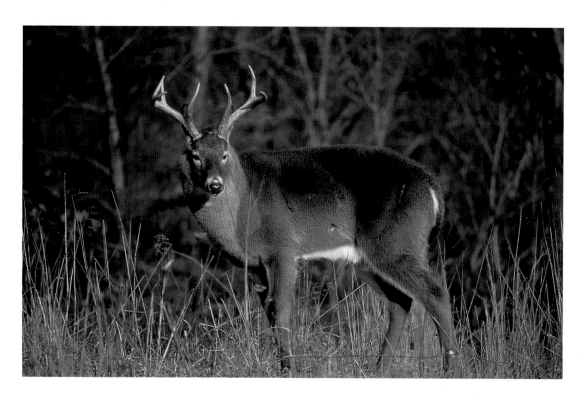

200–400mm lens with 1.4 teleconverter, Kodachrome 64 film, 1/125 sec., f/4.
Here a white-tailed buck shows extreme aggression with a "hard stare" and laid-back ears. The buck's body hair is standing on end, creating the impression of larger size. LEONARD LEE RUE III

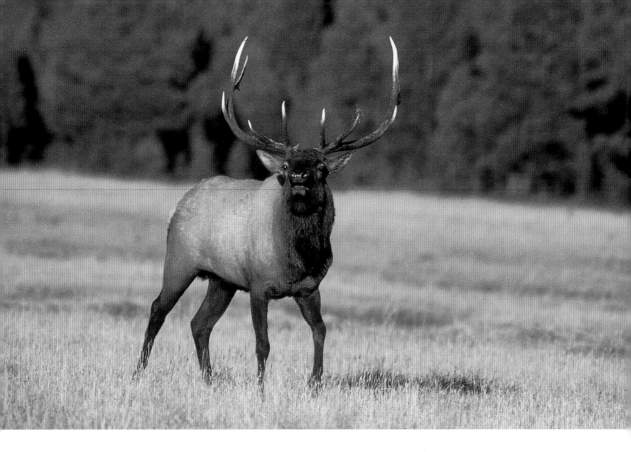

*200–400mm lens with 1.4 teleconverter,
Kodachrome 64 film, 1/125 sec., f/9.
This aggressive bull elk is preparing to start a
charge.* LEONARD LEE RUE III

rare and occurred because the rams want to use their regular trails when we happened to be on them.

There are always a number of incidents each year with bull elk in Yellowstone during the rutting season. And it's a wonder that it happens so infrequently. The tourists just don't show the big bulls any respect. They take their little 35mm cameras and try to fill the frame. To do so, they have to run up and practically stick the camera in the animal's face. Big bull elk work themselves up into a rage many times each day. They splinter the jack pine saplings and plow up and toss the earth with their antlers. They paw the earth with their feet. Any or all of these actions may be preliminary to charg-ing. Most often, tearing the turf and pawing mean the bull is making a wallow, but they could indicate aggression. Because we don't know what the bull might do, and perhaps even the bull doesn't know what he might do, it is wise to take heed. Another bad sign is when the bull raises his head and curls his lips up sideways like a dog snarling. When starting a charge, the bull usually lowers his neck and tilts his head up so that his antlers lie along his back. This is the same position he uses in herding his cows. If he is charging, at the last instant he drops his chin low, projecting his antler tines forward.

Bull moose are really a force to be reckoned with. The big Alaskan bulls stand over seven feet high at the shoulder and weigh over 1,500 pounds. Their legs are so long that they can walk over brush that we can't go through. An angry bull many slash his antlers against the brush, but more often, he tosses his head from side to side, setting

the pendant of skin under his neck flapping. He rocks his head so violently that only the whites of his eyes show. That's a very bad sign. In challenging a rival, a bull moose walks toward him, slowly rocking his antlers from side to side to make sure that the rival bull can see the mass of antlers he is carrying. Bull elk sometimes do the same thing, but I've never seen an elk challenge a human that way. Bull moose, however, have been known to attack cars, trucks, and even bulldozers.

As dangerous as a bull moose is during the rutting season, I believe that a cow moose defending her calves in the spring is even more so. I rate a cow moose defending her young to be as dangerous as a grizzly sow with cubs. The first indication of trouble is when the cow raises the long hairs of her mane on the top of her neck. She then lays her long ears back along her neck. Her tongue may loll out of her mouth eight inches or so. Then she charges. She has no antlers to hit you with, but she doesn't need them; she intends to stomp you down in the mud with her huge forefoot hooves.

Bison seem docile, sleepy, and, at times, stupid, but they are none of these things. The big bulls in the herds make the most noise and do the most jostling about, so

200–400mm lens, Kodachrome 64 film, 1/250 sec., f/8.
Bull moose challenge rival moose—and people—by rocking their huge antlers from side to side as they walk. LEN RUE, JR.

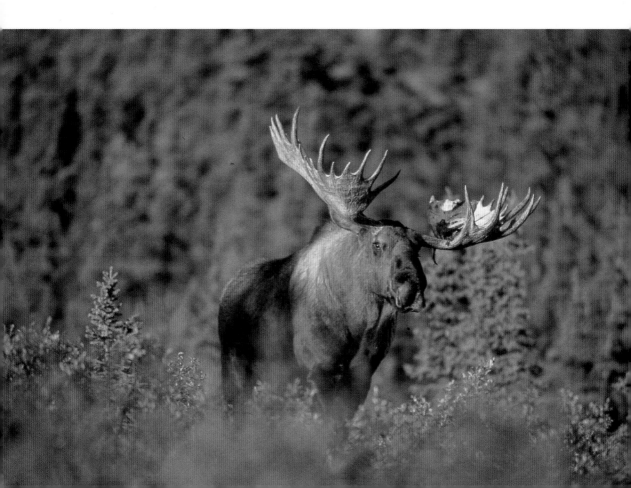

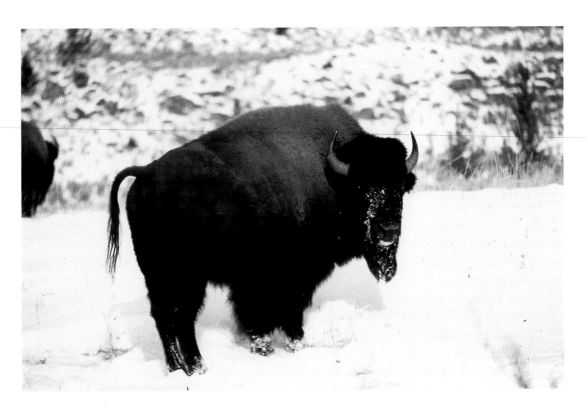

200–400mm lens with 1.4 teleconverter, Kodachrome 64 film, 1/125 sec., f/12.
As this shot was taken, this older bison bull began to raise his tail and roll his eyes—two signs of impending aggression. LEONARD LEE RUE III

most people avoid them. It is the old solitary bulls that have either left the herd voluntarily or been driven out by younger bulls that are the most dangerous. Like crotchety old men, these old bulls have short fuses. An angered bull may paw the ground and bellow. Most often he just rolls his eyes, showing the whites. He raises his tail so that it looks like a horseshoe or an inverted letter U. His tongue may protrude. When he starts to charge, his tail goes straight up, but by then it's too late.

Up until a few years ago, cougar attacks were extremely rare, because the big cats themselves were so scarce. Today, cougar attacks are no longer a great rarity. Given strict protection in many areas, the cougar population is increasing dramatically. Because they are territorial animals, young cougars are pushed out into areas where they are more likely to encounter humans. Our own population is constantly increasing, so that more people are invading areas that were once good cougar country. Conflict is inevitable. All the actions of an angry house cat are made by an angry cougar: the flattened ears; the snarling, raised lips; the hissing; the lashing of the tail. A cougar about to attack may not snarl or hiss, however. It starts from a crouch, with its ears back and its tail moving from side to side. Don't run; use a pepper spray or even begin to charge the cat; most can be driven off.

13

My good friend Gary Alt, Pennsylvania's expert bear biologist, says that he knows of no documented attack by a black bear on a human in the state of Pennsylvania. All the aggressive bears were killed years ago, and Pennsylvania's current huge black bear population is descended from the bears that ran. Black bear attacks in other parts of the continent do occur, however, and people have been killed. Black bears are generally more docile than grizzlies. Most people run into trouble with bears because they surprise them. They go over a ridge and find themselves face-to-face with a surprised bear. If the bear is defending a carcass or cubs, it will probably charge instinctively. Walking the trails in bear country, I always wear "bear bells" in an effort to avoid surprising bears; the noise lets them know that I'm coming.

Don't approach a bear any closer than 100 yards, if possible. A bear standing on its hind legs is not showing aggression; a bear that has its ears laid back, swings its head from side to side, and pops its teeth is. When bears stand on their hind feet, it is usually to get a better look at whatever got their attention. They also sniff the air for scent to determine what disturbed them. Their eyesight is poor, but their noses are infallible. Also, by standing on their hind legs, they show their size, and size denotes dominance.

If you are confronted by a bear, *do not run.* Running makes you a prey species and stimulates the predator instinct in the bear. Back away slowly. If the bear becomes more aggressive, blow your whistle, make lots of noise to make sure the bear knows it's attacking a human. Then use your pepper bear spray; it's been proven to work. If you are attacked, all the experts agree that you should lie down on your stomach or on your side in the fetal position, clasp your hands behind your neck, and play dead.

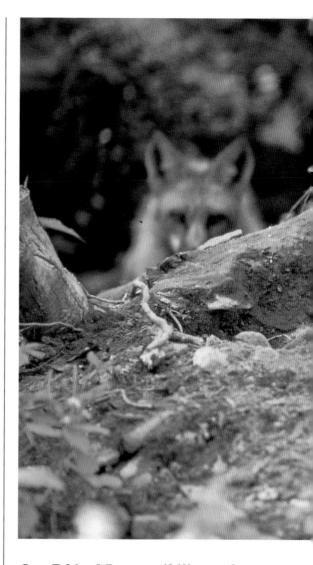

Our Ethical Responsibility to the Wildlife We Photograph

Nature has designed all species with a series of checks and balances. No predator eliminates its prey species. As a prey species population is decimated, the fecundity of the predators is greatly reduced. When a prey species rebounds, the numbers of the predators also increase. There has always been this pendulum swing between highs and lows.

It is vital that we, as photographers, do

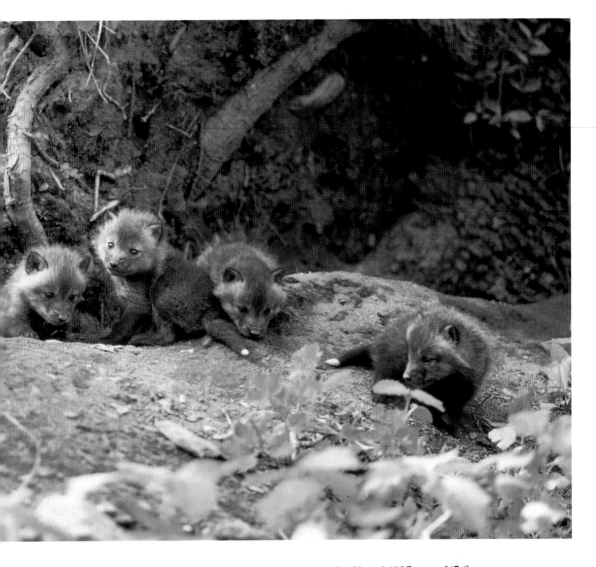

200–400mm lens with 1.4 teleconverter, Kodachrome 64 film, 1/125 sec., f/5.6.
Here a male red fox watches over his one-month-old pups at the natal den. LEN RUE., JR.

nothing to increase the predation of the species we photograph. A couple of years ago, a biologist out west was doing a research project on pronghorn antelope. Watching the pronghorn from a hilltop with binoculars, the biologist located all the hidden antelope fawns in the area when the does went to nurse them. He proceeded to tag all the fawns. The coyotes in the area then followed his tracks to the fawns and killed and ate them.

If you plan to photograph young animals, do so from a distance; don't go directly to them. Don't touch the young or move them to a more favorable spot, because if your scent is on them, the mother may not come

15

back to them. Research has shown that 90 percent of wild white-tailed deer do return to their fawns after they have been handled by biologists, but that means that 10 percent do not. Don't be responsible for that loss.

If you try to work too close to fox, coyote, or wolf dens, the adults will move them. They usually have a second den already selected to be used in such an event, but the pups may be put in danger by the process of being moved. And the second den is not going to be optimal, or it would have been used in the first place.

Harassment of Wildlife

We hear a lot about the harassment of wildlife by wildlife photographers, but it doesn't happen as frequently as is often claimed. In some parks, it is considered harassment if an animal raises its head, raises its tail, gets up if lying down, moves off, or does any of the other things that wildlife *normally* does in the course of a day.

Feeding animals constantly stop feeding and raise their heads. Any animal that does not practice such vigilance is not going to be around long. All the grazing and browsing animals move often while feeding. The prey species' greatest safety lies in constantly moving to keep predators on the move too, increasing the chances that the prey species will discover them. Prey species also keep moving to prevent the destruction of vegetation. Light feeding on a plant is like pruning; it stimulates more robust plant growth. Overbrowsing or overgrazing destroys the plant's ability to reproduce the lost parts, causing it to die. So these animals take just a few bites before moving on to the next plant.

Animals frequently raise their tails. Many animals jerk, wag, or raise their tails before moving. All animals raise their tails to defecate. Deer, sheep, goats, and antelope defecate an average of about 36 times in a 24-hour period. That means that they have to raise their tails at least once every 45 minutes.

All this means that animals move so often during the course of a day that you will have ample opportunity to photograph it in various stances without resorting to harassment. Patience is the key.

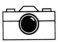

The Equipment

Cameras

Len Rue, Jr.

The last 25 years have seen major technological advancements in photographic equipment. The 35mm camera has gone from a manual, mechanical instrument to one that is loaded with electronics. It can be fully automatic not only in exposure control and film advance but also in focusing, design, and advanced optical technology. When combined with the new designs and advanced optical technology of today's lenses, the end result is the superior image quality necessary for wildlife photography.

The Basic 35mm Camera

Single lens reflex (SLR) means that the photographer composes and focuses the subject through the same lens that records the image on the film. This is done by way of a mirror in the camera that springs up out of the way when the shutter is tripped. Except for a couple of range-finder camera models, such as the Leica M camera series, almost all 35mm cameras today are SLRs.

This is the ideal design for mammal photography because it allows the photographer to view exactly what will be recorded on the film. The 35mm camera system is fairly compact and lightweight, making it ideal for fieldwork. This might be disputed by anyone who has had to carry a large tele-

photo lens up a mountain, but it is less bulky than the old large-format cameras.

One of the most important considerations when purchasing a 35mm camera system is to make sure that it has the capabilities you need, with room to grow. Buy a system that is versatile, with a wide range of lenses and other accessories to meet special photographic needs as they arise. Try to think ahead several years to what you might want to do with your photography and then select an appropriate camera system.

Most name-brand camera systems are good for mammal photography. The most widely used brands for this type of photography, however—especially if you plan to do professional photography—are Nikon, Canon, and Minolta. These three manufacturers are in stiff competition with one another and are constantly introducing new and improved products. This makes their camera systems the most comprehensive in the industry.

These three companies, as well as others, offer a wide range of cameras, from top-of-the-line professional models down to beginner-level cameras, that all use the same system. This means that a beginning photographer can purchase a simple camera model that uses the same lenses that the top-of-the-line models use. This compatibil-

ity enables a photographer to grow within a camera system without incurring unnecessary expense.

All 35 mm cameras require some basic features for wildlife work.

Motor Drive. Motorized film advancement is extremely important. Most modern cameras have built-in motor drives. On older, manual cameras, a motor drive or winder was an add-on accessory. The ability to quickly advance the film (up to five frames per second), shot after shot, is a desirable feature for wildlife photography, especially for continuous action sequences. The photographer's concentration is disrupted when the camera shutter must be recocked and the film advanced by hand. Although this may not seem like a major problem, it is just one more thing to be thinking of when you should be devoting your entire attention to capturing the action on film. This is especially true when you are photographing animals, which are constantly moving. Your subject may hold

80–200mm zoom lens, Fuji professional film, 1/500 sec., f/3.5.
A motor drive is indispensable in photographing fast-paced action sequences. While I was photographing a pack of wolves under controlled conditions in Montana, these three wolves raced by me—the more dominant wolves are biting the wolf in front. I photographed them with a zoom lens on a motor drive–equipped camera, panning with the subjects and exposing a sequence of shots at five frames a second. LEN RUE, JR.

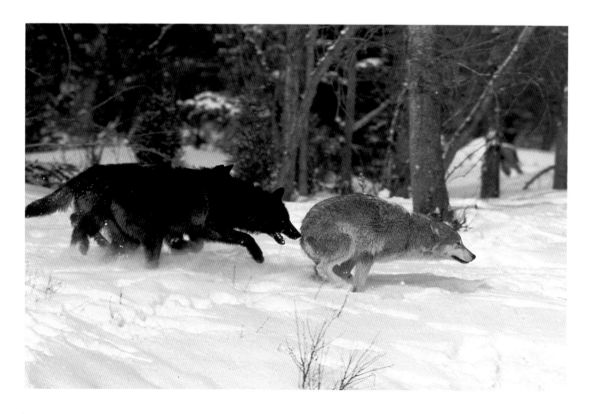

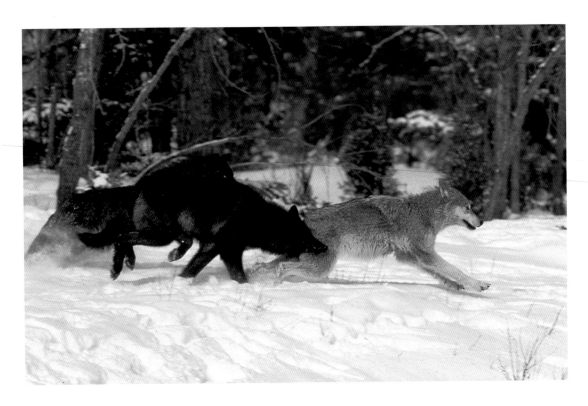

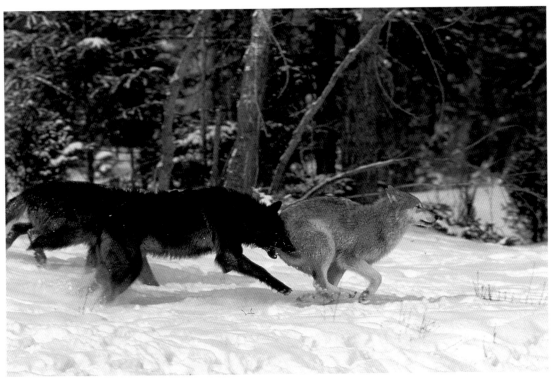

that perfect pose for just a few seconds, and you don't want to waste any time advancing film, recomposing your photograph, or refocusing on your subject.

In addition to advancing film, a motor drive usually has a film rewind capability. To have the roll of exposed film automatically rewind so that you can quickly remove it and reload the next roll can be as important as film advance when you are in the middle of photographing fast action.

Interchangeable Focusing Screens. Having the ability to interchange focusing screens can also be useful. In recent years, technology has made focusing screens brighter, thus making it easier to compose and focus the image. Most manufacturers offer a number of different screens to meet the needs of various applications. Screens are available with matte/Fresnel, fine ground

600mm lens, Kodachrome 64 film, 1/500 sec., f/4 (deer).
80–200mm zoom lens, Kodachrome 64 film, 1/500 sec., f/5.6 (cougar).
We focused both of these images manually. It is always more difficult to manually focus and obtain a sharp image of a subject that is moving straight toward or away from you as opposed to a subject that is moving perpendicular to your position. This means that you would have a better chance of taking a greater percentage of sharp images of the cougar than you would of the deer. When manually focusing such fast-paced action, keep in mind that the majority of the images shot will not be sharp. The latest auto-focus cameras, however, are so good that a much greater number of sharp action images can be captured on film. LEN RUE, JR. (BELOW)
LEONARD LEE RUE III (OPPOSITE)

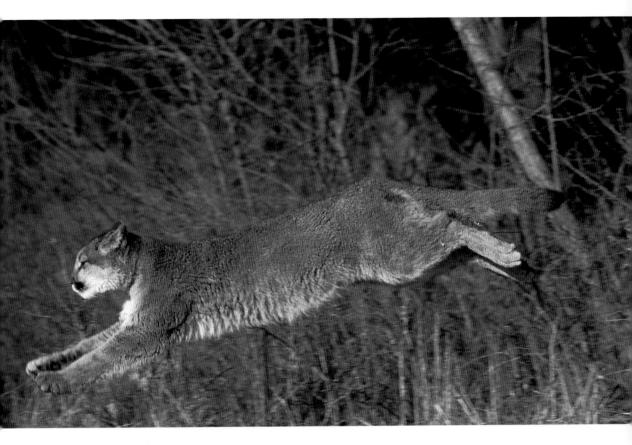

matte, and clear Fresnel fields and are obtainable with microprisms, focusing spots, split-image range finders, crosshair measuring scales, and grid lines. Since so much mammal photography is done with long telephoto lenses, focusing screens that are bright and have limited markings (such as a spot meter reference circle in the middle) tend to work best. Most focusing screens that come as standard equipment in today's cameras work fine for mammal photography. Another screen that I have found useful is one with grid lines, which help in lining up the horizon or anything else with straight lines.

Depth-of-Field Preview. I would not buy a camera today if it did not have a depth-of-field preview button. Depressing this button closes the lens down to its working aperture (the f-stop at which the lens is set), thus showing what the depth of field will be at that f-stop. Since so much of wildlife photography is done with telephoto lenses, which have shallow depths of field, it is important to be able to visualize exactly what will be sharp in the photo that you are about to take.

Focal Plane Shutter. Almost all 35mm cameras have focal plane shutters. This type of shutter consists of a curtain that opens just in front of the film. It was traditionally made of opaque cloth, but high-tech materials such as titanium are now used. Older cameras used to have a top shutter speed of 1/1,000 or 1/2,000 of a second. From a practical standpoint, with the slow- to medium-speed films that most people use for wildlife photography, you will

21

never need the 1/4,000 or 1/8,000 shutter speeds that are now available on some models. In all my years in photography, I have only occasionally used 1/2,000 of a second. Most exposures are usually in the 1/60 to 1/1,000 of a second range.

Mirror Lock. A mirror lock-up is almost never used when doing wildlife photography because it works only on stationary subjects. But being able to lock the mirror up out of the way minimizes vibrations when doing long time exposures, such as in close-up and night photography.

Manual Cameras

A manual camera is like an old watch; it runs on springs and gears. These cameras operate without battery power, and the photographer must manually set the aperture ring and the shutter speed for exposure control and must manually focus the lens. Rewinding the exposed film is also done manually.

There must be millions of these cameras still in existence, because this was the only kind of camera available until the 1980s, when electronics ushered in the age of automation. Many of these cameras can be picked up quite inexpensively on the secondhand market. There are also some excellent manual cameras still manufactured, such as Nikon's FM2 and Canon's F1 cameras. These cameras are great for people who like to take the traditional approach to photography and do everything themselves. A manual camera is also a good learning tool for anyone who is starting out in photography and wants to learn the basics.

Nothing drains batteries like severe cold, and since manual cameras do not require batteries, they are good to have along on trips to the Arctic and other areas of extreme cold, where electronic cameras will go through an inordinate amount of batteries or may refuse to work at all. As long as all lenses and accessories of your current camera system fit, a manual camera is a good choice for a backup.

The main disadvantage of a manual camera for wildlife photography is that you will have a hard time capturing high-speed action on film because your response time is not as quick and accurate as it would be if you used a modern camera set on auto-focus, auto-exposure, and auto-wind.

Automatic Cameras

Today's modern 35mm camera is a marvel of technology. Through advancements in computer technology and the miniaturization of chips, the latest camera models are fast, accurate, and reliable in all their various automatic functions. Microprocessors inside these cameras have taken a lot of the guesswork out of photography. In fact, the more sophisticated they become, the more user-friendly they seem to be.

What it really comes down to is options—options that photographers now have available that they didn't have before. Photographers must still create a photograph as it is envisioned in the mind, but now the tools for doing the job are much better. Perhaps the biggest challenge in mastering these cameras is learning what functions work best for the photography that you are doing and deciding when to override the automatic function and doing it yourself manually. This ability to override the automatic features, especially in focusing and exposure, is an important feature.

Let us now take a closer look at the automatic features that are commonly found in today's cameras.

Auto-Focus. I consider cameras such as the Nikon F4, introduced in 1988, to be examples of second-generation auto-focus cameras. These auto-focus systems are quite accurate on animals that are stationary or moving slowly. The minute the action picks up, however, these auto-focus systems cannot keep up.

Now, with ever faster computer chips in the cameras and high-speed focusing motors built into the lenses, third-generation cameras, such as the Canon EOS 1N and Nikon N90s, deliver extremely fast and accurate auto-focusing. With the development of a fully electronic mount and the auto-focus drive ultrasonic motor for its EOS system, Canon was the first to incorporate these high-speed focusing motors in each lens for increased focusing speed and efficiency. Over the last couple of years, the Canon EOS system has gained many converts among professional wildlife and sports photographers, whose livelihoods depend on capturing fast-paced action on film.

Nikon has followed suit by designing a DC coreless auto-focus drive motor that is now used in its D series of telephoto lenses. These D lenses are very fast when used in conjunction with Nikon's new N90s camera.

Minolta's auto-focus system also deserves a good look, especially when its long lenses are teamed with its newest camera models, such as the 7XI and 9XI, which are on the cutting edge of technology with an auto-focus system that is fast and accurate.

Most major camera brands now offer auto-focus. If possible, you should try out the auto-focus system of the camera you are interested in through a friend or a camera store, to make sure that it does the job you expect it to.

Although they are not infallible, these new auto-focus systems provide a greater percentage of usable or acceptable images in action sequences than a photographer could hope to achieve by focusing manually. And as a professional photographer, I can vouch for the fact that there is much more interest and sales potential in photographs depicting action or behavior of animals than in photographs that show animals in stationary poses. A deer running across a field or a cougar jumping off a rock ledge can now be accurately auto-focused.

There are several auto-focus modes that are commonly found on today's cameras. Usually selected for use when photographing a stationary subject, single mode is pretty straightforward. When the shutter release button is depressed, the camera auto-focuses onto the subject and then holds focus until the shutter is completely depressed and the photograph is taken. Since animals are usually moving, single mode is not practical for shooting wildlife.

The second mode is focus tracking, or predictive focus. It is this mode that wildlife photographers find most useful. Information regarding the subject's direction of movement and speed is monitored and fed into the microprocessor, which then follow-focuses the subject and predicts the exact distance to the subject. In this way, the image is sharp when the shutter is tripped.

The third auto-focus function is focus confirmation. This usually consists of three diodes in the viewfinder—two red, with a green one in the middle. These diodes light up to indicate whether the subject is in sharp focus. Although this is a function of the auto-focus system, the focus confirmation lights also operate with non-auto-focus lenses. This feature is most useful when photographing in dim light.

For all the benefits of auto-focus, it is not problem free. One of the biggest handicaps has been the location of the auto-focusing spot in the center of the viewfinder, which means that it doesn't work well for subjects that are off center. To help alleviate this problem, cameras now come equipped with an auto-focus lock button. The photographer centers the focusing spot on the subject and then depresses the auto-focus lock button. This locks the focus, allowing the subject to be placed off center for better composition while still maintaining correct focus.

Manufacturers continue to work on this problem. Nikon, in its N90s camera, offers a

wide-area auto-focus spot in addition to spot auto-focus. Canon's latest EOS models offer five auto-focus spots, any one of which the photographer can activate. Alternatively, all five focus spots can be automatically activated by the camera, which means that each of the five spots activates as a subject moves across the viewfinder.

Another problem can occur when trying to photograph a subject that is moving through brush, tall grass, or trees that come between the camera and the subject. This sometimes causes the auto-focus system to lose its lock on the subject. At such times, overriding the system and focusing manually may be the best solution.

Although auto-focus can't do it all, it has become a valuable tool for wildlife photographers. I highly recommend auto-focus capability for anyone buying a 35mm system.

Auto-Exposure. The f-stop–shutter speed relationship determines how much light reaches the film—the exposure. The more the diaphragm, or aperture, in the lens is closed, the less light reaches the film. F numbers signify how much the diaphragm is closed. For example, an f/2.8 on an f/2.8 lens signifies that the aperture is wide open, allowing in a lot of light. Each time the aperture is closed down one stop, say from f/5.6 to f/8, the amount of light reaching the film is cut in half. In order to maintain the same exposure on the film, whenever the lens aperture is closed down, a slower shutter speed must be used. Thus, 1/500 second at f/5.6, 1/250 second at f/8, and 1/60 second at f/16 all provide the same exposure on the film. The shutter speed–f-stop combination you choose depends on what you want to emphasize in your photograph.

The first auto-exposure function on cameras was A for aperture priority, in which the f-stop is selected by the photographer and the camera automatically selects the proper shutter speed. When photographing animals that are moving, usually the most important consideration is having a fast enough shutter speed to stop the action. Thus, when photographing action with aperture priority, it is best to choose a large f-stop—f/5.6 or f/4, or perhaps even shooting with the lens at its maximum aperture (wide open). This forces the camera to choose a fast shutter speed, which is required to stop the action and capture a sharp image on the film. If an animal subject is lying down or not moving, you may decide to close the aperture of the lens down partway to gain a little more depth of field in the picture. It is not beneficial to gain greater depth of field, however, if you sacrifice sharpness of subject to achieve it.

Depth of field is how much of a photograph, from foreground out to infinity, is in sharp focus. Depth of field is determined by the focal length of the lens and the aperture (f number). The longer the focal length of the lens, the shallower the depth of field. As a general rule, telephoto lenses have shallow depth of field, and wide-angle lenses have great depth of field. If you shoot with your lens wide open, you will have shallow depth of field, which means that the subject will be sharp but the foreground and background will be out of focus. As the lens is closed down (higher f numbers), more of the foreground and background areas come into sharp focus.

Most lenses provide peak optical performance, with the least amount of aberration, at f/4, f/5.6, f/8, and f/11. A lens closed all the way down to f/22 or f/32 loses some optical quality. Lenses shot wide open tend to have a slight degree of optical distortion, but high-speed telephoto lenses using low-dispersion glass provide remarkably good image quality when shot wide open.

In addition to aperture priority, almost all automatic cameras manufactured within the last six years also offer shutter priority

and one or more program modes. In S (shutter priority), the photographer selects the shutter speed to be used and the camera automatically chooses the proper aperture opening, or f-stop.

Since capturing animal action is of primary importance to wildlife photographers, shutter priority can be quite useful. For example, let's assume that you are in Yellowstone Park and you want to photograph a coyote as it jumps on a mouse. If you are using fast enough film and a lens with a large enough f-stop, you can use shutter priority and choose a fast shutter speed, such as 1/1,000 second, that will capture the action on film, knowing that the camera will automatically provide the correct exposure by selecting the proper f-stop.

In program mode, the camera automatically selects both the shutter speed and the f-stop. I seldom photograph in program mode, because I believe that I know better than the camera whether a particular subject requires a greater depth of field or a faster shutter speed.

In an attempt to have the program mode better respond to the needs of photographers, some cameras now offer several different program modes. One of these is a high-speed mode that does not allow the shutter speed to drop below 1/125 of a second. Keep in mind, however, that even this shutter speed is too slow for capturing most types of animal action.

Another development that is beginning to show up in some of the latest cameras, such as the Nikon N90s, is a multipurpose mode in which the photographer tells the camera the type of photograph to be taken, such as portrait, sports, close-up, landscape, silhouette, and so on. Then the camera selects the proper exposure, with emphasis on speed or depth of field, for each type of subject, based on the information programmed into the camera's computer.

Exposure Meter Modes. Throughout the 1970s, most built-in camera meters incorporated some type of center-weighted metering pattern. In addition to this, most new cameras offer the choice of a matrix, or evaluative, metering pattern and spot metering.

A center-weighted metering pattern assumes that the subject is usually located in the center of the format, so 60 to 75 percent of the exposure reading is taken within the small circle located in the middle of the focusing screen. The rest of the area within the viewfinder makes up the remaining 25 to 40 percent of the meter reading. Photographers, through experience, learned the limitations of this type of meter reading and how to compensate for it.

Although it is not infallible, matrix, or evaluative, meter reading capability is a major technological advance that has helped many photographers achieve a much higher percentage of properly exposed photographs. This is especially true for scenes with unusual or troublesome lighting conditions.

By utilizing the in-camera computer, the meter evaluates the brightness in as many as 16 different segments of the scene in the viewfinder. The computer then analyzes this information and determines the proper exposure for the part of the scene that it considers most important by comparing it with exposure values programmed into the computer.

Matrix metering works well with autoexposure, practically turning the camera into a point-and-shoot camera. Matrix metering can give false readings under certain conditions, however, such as when photographing predominantly white snow scenes. The section on exposure covers this in greater detail.

A new development that further refines exposure meter readings is the integration of subject-to-camera distance information,

which is taken from the auto-focus system and is entered into the exposure metering system. This allows the meter to calculate and emphasize proper exposure for that part of the scene that is in sharp focus, which is almost always the main subject.

The spot meter mode allows the meter to read only the center spot of the viewfinder, which is usually about 3 percent of the total viewing area. In wildlife photography, spot metering is useful. Once, while I was photographing in southern Texas, a huge white-tailed buck stepped out of a dark background into late afternoon, low-angle side light. I was able to obtain a proper exposure by switching to spot metering and locating the circle directly on the deer. This eliminated the background so that it did not adversely affect the meter reading. In the course of doing wildlife photography, you will often be faced with unusual or difficult lighting conditions, and the judicious use of spot metering can solve the problem.

Exposure Lock Button. Depressing this button simply locks the exposure reading until the shutter release is completely depressed and the photograph is taken. This allows the photographer additional control over exposure when the camera is operating in one of the automatic exposure modes.

Being somewhat old-fashioned, if I run into a difficult lighting situation in which I may need to use the auto-exposure lock button, I usually find it easier to disengage the auto-exposure mode and shoot manually.

Exposure Compensation. The exposure compensation dial is an override feature that may be used when the camera is operating in one of its automatic exposure modes. This dial allows you to either underexpose or overexpose your photos, usually in one-third f-stop increments, from the normal exposure that the camera has chosen. This control can be useful to compensate

for white or black backgrounds, which can adversely affect the exposure meter reading, or to correct an exposure meter that might be slightly off in its readings. If you are using a camera that does not have this dial, you can do exposure compensation by manually adjusting your film ISO dial up or down from the film's rated speed.

DX Film Rating. Most automatic cameras today read a code right off the side of the film cassette that tells the camera what speed film is being used, so that the film's ISO rating is automatically set in the camera. For a photographer who is constantly switching back and forth between different types of film, this feature can be a real plus.

If you find a specific film consistently producing finished transparencies that are either lighter or darker than you like, you may need to set the film speed manually in order to adjust the ISO rating slightly to meet your expectations for the proper exposure.

TTL Flash. I would never buy a camera without through-the-lens (TTL) metering capability. Although I don't use it a great deal, the new electronic flash systems that read both ambient and strobe light output right off the film plane make it a snap for anyone to take top-quality, professional-looking fill-flash photographs.

Fill flash lowers the lighting ratio for existing light photography by lightening up dark shadow areas for a more pleasing photograph. For more specialized types of photography, such as night photography or teleflash photography, TTL metering does away with all the flash calculations that used to drive everyone to distraction.

Most of the new cameras have effective shutter sync speeds of 1/250 of a second. This is a major plus when trying to balance flash to daylight; old cameras used to have flash sync speeds between 1/60 and 1/80 of a second.

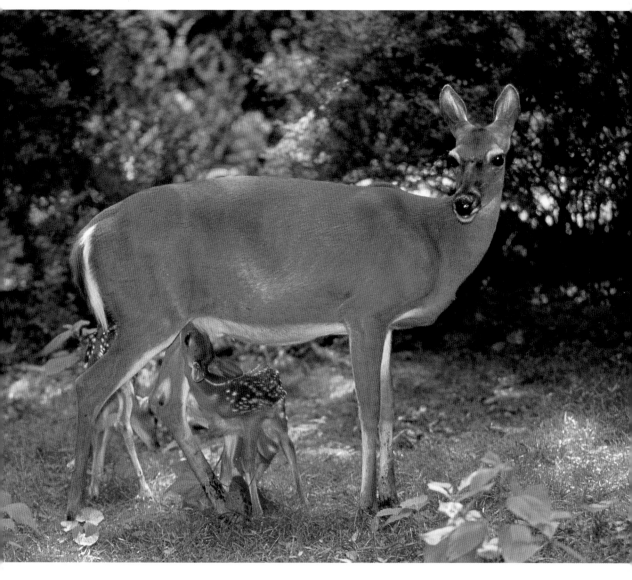

80–200mm zoom lens, Fuji 100 professional film, 1/125 sec., f/5.6.
Many times, when shooting with available sunlight in forest habitat, the light falling on the sub-
ject will be mottled with a high lighting ratio, which is undesirable. This can be corrected by
using a small fill flash balanced to daylight, which puts more light into the shadowy areas and
lowers the lighting ratio, for a more acceptable photograph. The equipment used for this shot
was a Nikon F4s camera with an SB-24 strobe light and a zoom lens with matrix metering, which
enabled the camera to automatically set the exposure and the flash output for proper synchro
sunlight. LEN RUE, JR.

Multi-Control Back. If today's automatic cameras still don't have enough features for you, you may choose to purchase an optional multidata or multicontrol back. One such back provides data imprinting on the slide, time-exposure durations up to 99 hours, all-mode exposure bracketing from 3 to 19 frames in one-half–stop increments, multiple exposures for up to 19 exposures on one frame, and focus priority lock.

For mammal photographers, focus priority lock is probably the most important feature of a data back. If you are interested in doing remote setups, such as setting your camera and strobe lights along a game trail, this function automatically trips the camera shutter at the precise instant that the subject is at a prefocused distance and is in sharp focus.

No matter how sophisticated and accurate these cameras become, however, they can't take the place of a photographer's experience and knowledge. Camera manufacturers are trying to make these cameras foolproof, but they aren't there yet, and they probably never will be. I view all the automatic functions as convenient tools that help me do a better job. Perhaps the biggest challenge in using these cameras is to know when it is best to override some of the automatic functions and shoot manually, by relying on your own experience and knowledge. The point is to make the new technology work for you; don't let it control you.

Lenses

Len Rue, Jr.

The lens is the eye of the camera. It is the lens that brings the image of the subject into sharp focus at the film plane for reproduction onto the film. So it's safe to say that the image quality of the transparency or negative is more the result of your choice of lens than almost any other decision you make.

There are many factors that need to be taken into consideration when choosing a lens, including the quality of the lens, how well it suits your photographic needs, and how much it costs. Before any purchase is made, it is essential that you take a good, hard look at what you want to do with your photography and decide what animals you are most interested in photographing.

Mammal photography involves photographing everything: small animals, such as field mice, squirrels, and rabbits; quick-moving animals, such as foxes and coyotes; animals that are usually photographed in controlled environments, such as mountain lions and bobcats; and the whole range of big-game species, including deer, elk, pronghorn, caribou, moose, mountain sheep, mountain goats, and bears, which are usually wary of photographers and often dangerous, requiring that they be photographed from a safe distance.

Knowing what you want to photograph will help you decide which lens will best suit your needs. No one lens will do it all, and you will always want more—something newer, something faster, or something bigger. Focal length is the primary consideration when buying a lens. The longer the focal length of a lens, the more the image size is magnified, and the larger the image is reproduced on the film. Increasing the focal length also decreases the degree of coverage. For example, a 24mm wide-angle lens has an angle of coverage of 84 degrees, whereas a 600mm telephoto lens covers only a little over 4 degrees. Finally, the longer the focal length of a lens, the shallower the depth of field. This is why telephoto lenses not only magnify the subject and eliminate other elements of the scene with their narrow coverage but also help make the subject stand out by throwing the background out of focus.

As a general rule, I suggest that you buy

the best lens you can afford in the focal length you have chosen. Other criteria that determine both performance and price are maximum aperture (the faster lens, the more expensive it is), type of optical glass used (which determines optical quality, especially in telephoto lenses), whether or not it has internal focus, and if there are matched teleconverters in the 1.4X and 2X ranges that will extend the lens's effective range.

Normal Lenses

Most cameras come with a 50mm, or normal, lens. The 50mm lens has an angle of coverage of about 46 degrees—approximately equivalent to what the human eye sees. This type of lens, unless it is a macro or close-focusing design, is virtually useless for wildlife photography; the focal length lacks the magnification that is required for photographing small or distant animals.

It is my recommendation that you buy only the camera body and purchase your lenses separately or that you ask the salesperson to replace the normal 50mm lens with a 50mm or 60mm macro lens. You can use the macro lens for general photography purposes, such as children's birthday parties, family gatherings, and the like, but it will also allow you to take close-ups of small creatures, flowers, insects, and the like.

Wide-Angle Lenses

Any lens with a focal length below 50mm is considered wide angle. I always carry a 24mm wide-angle lens with me for scenic photography. I also own an 18mm lens, which is useful for dramatic wide-angle effects. They have little practical function in mammal photography, however, except when photographing an animal as one small element in a large landscape, such as when it is important to depict an animal subject surrounded by its environment.

Telephoto Lenses

Most mammal photography is done with telephoto lenses ranging from 300 to 800mm. The 80–200mm or 70–210mm zoom lenses are popular for photographing animals that are relatively closer. It doesn't take a photographer long, however, to realize that a 200mm lens doesn't have the magnification and reach required to get top-quality photographs of many mammal species. Most manufacturers offer 300mm (6X magnification), 400mm (8X magnification), 500mm (10X magnification), and 600mm (12X magnification) lenses. A couple of companies offer 800mm (16X magnification) lenses.

I use a 300mm lens for animals that I know I can approach fairly closely. I own a 300mm f/2.8 lens, which is the longest lens that I feel comfortable shooting off a shoulder stock. It has never been my main lens, however, because it is too short for many species.

If I could have just one telephoto lens, my choice would be a 400mm lens. A lot of other people must concur, because several manufacturers offer this length lens in a number of different variations of optical glass (regular and apochromatic) and aperture speed (f/2.8, f/3.5, f/4, and f/5.6), so it is available in different price ranges. The slower f/5.6 lenses are quite compact, weighing only about two to three pounds, and are easy to handle. The huge f/2.8 lens excels at capturing action in low light, such as early morning or evening, when animals are most active. Either the f/3.5 (which I have) or the f/4.5 version is a good compromise, in that both have pretty good speed yet are small enough to be fairly maneuverable, weighing about five to six pounds. The 400mm lens is large enough that it works well on most big-game species, provided you can get within about 150 feet of them. At this distance, you will be able to record a decent size image on

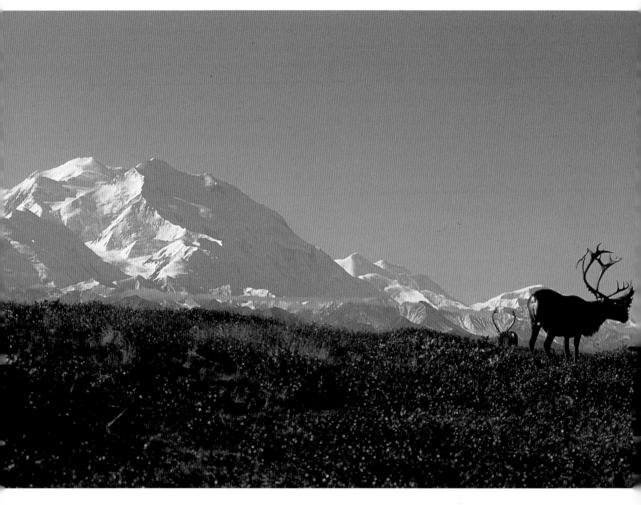

200–400mm zoom lens, Fuji 100 professional film, 1/250 sec., f/9.
If you are far enough away from your subject, vistas can be photographed with telephoto lenses.
This scene of Alaska's Mount McKinley, which includes a caribou bull as part of the composition,
was photographed with the lens set at about 300mm. LEN RUE, JR.

the film without frightening the animal. And if you are working on an aggressive subject such as a bull elk in the rut, that distance should give you enough time to get behind something if you are approached by the animal. This size lens also works well on smaller animal subjects at close range.

The 500mm lens has become popular since the late 1980s. Its main advantage over the 400mm lens is a slightly longer reach, which slightly increases your working distance. With some species, this lens is a little more than you need, but it can be a plus if your subject is extra wary—or extra aggressive. Depending on the manufacturer, these lenses usually have a maximum aperture of f/4 to f/4.5 and weight from 6$\frac{1}{2}$ to 10 pounds.

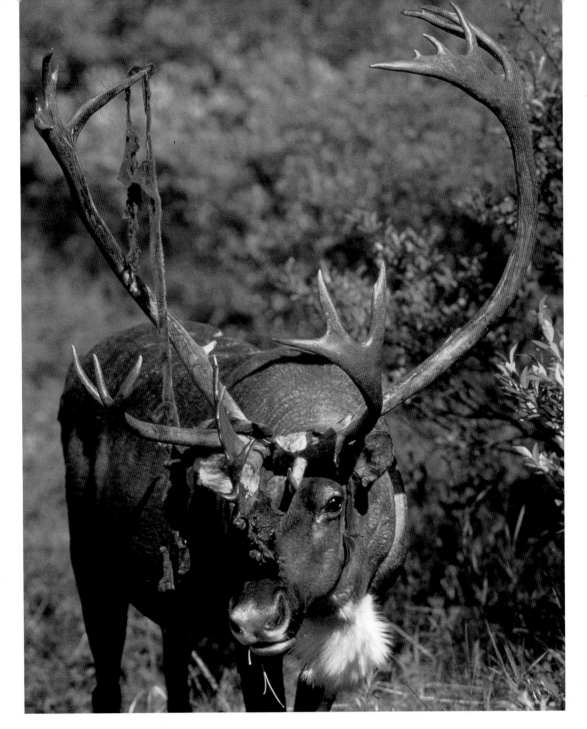

200–400mm zoom lens, Kodachrome 64 film, 1/125 sec., f/11.
This caribou bull with the velvet peeling from its antlers was photographed with a zoom lens at its maximum setting of 400mm. When photographing wild animals, a long telephoto is a must if close, tight portrait photographs (such as this one) are desired. LEN RUE, JR.

Many people dream of owning a big 600mm f/4 lens. For a lot of mammal subjects, however, the extended reach of the 600mm lens is overkill. I use this lens mainly for bird photography, but there are times that I find it useful for working with mammals. In Alaska, the 600mm is my main bear lens. When photographing at Katmai National Park, this lens was perfect for shooting bears on the far bank at Brooks Falls. In Denali National Park, where most of the photography is done from the road and the habitat is open tundra with large vistas, a big 600mm lens reaches out and brings closer the grizzly bears and the occasional wolf or red fox that may go by. I often use the 600mm lens for smaller mammals too, such as muskrats at a pond. Weighing in at almost 14 pounds, a 600mm f/4 lens provides a workout if you carry it far. This focal length is also available in slower maximum apertures from f/5.6 to f/8, which are both lighter in weight and less expensive.

There are always going to be times when you wish you had a lens with more reach, but I have never felt a great need to own an 800mm lens for mammals. Photographing subjects over great distances can degrade the image quality, no matter how good the lens, because of atmospheric haze, heat shimmer on warm days, and vibration in the equipment.

Years ago, telephoto lenses were not as sharp as normal lenses because of chromatic aberration. As wavelengths of light pass through regular optical glass, the blue, green, and red parts of the spectrum are each bent slightly differently and cannot focus together at the film plane. This can adversely affect the sharpness of the entire image. The longer the telephoto lens, the worse the aberration. To combat this problem and dramatically improve the quality of images taken with telephoto lenses, the major camera companies developed glass specifically designed to keep the red, green, and blue wavelengths in sharp focus. In 1975, Nikon developed its extra low dispersion (ED) glass, and Canon came out with telephoto lenses featuring both fluorite crystal and ultra-low-dispersion (UD) glass. Today, most of the major camera companies and lens manufacturers offer versions of low-dispersion glass with various designations such as APO, ED, UD, and L. Telephoto lenses that use this glass deliver images that are extremely sharp and crisp and show good contrast.

The high optical correction properties of these special glasses also enabled the manufacturers to develop high-performance telephoto lenses featuring fast maximum apertures (f-stops). Fast-aperture telephoto lenses with special glass are expensive. For example, a major brand 400mm f/5.6 ED lens costs about $2,000, a 400mm f/3.5 ED lens costs about $4,000, and a 400mm f/2.8 ED lens costs about $6,400. Lenses from independent lens manufacturers can be purchased for less, with some 400mm lenses listing for as little as $500 to $600. Slower speed lenses featuring this glass are also less clostly. Fast-aperture telephoto lenses allow you to shoot at a faster shutter speed, however, which is important when photographing animals in action. Because of the special glass, image quality remains excellent even when the lenses are shot wide open.

Another desirable feature is internal focusing. With most conventional lenses, the length of the lens physically expands as it is focused out for objects that are close. This cuts down on the amount of light reaching the film, and the front lens element usually turns, making it more difficult to use some types of filters, such as a polarizer. As front lens elements are moved back and forth, weight balances can shift. Internal focusing shifts elements internally, which keeps the physical length of the lens the same, and there is no loss of light.

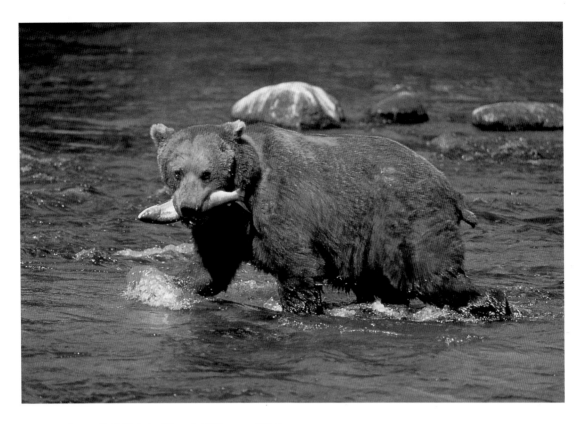

600mm lens, Fuji Velvia film, 1/250 sec., f/5.6.
The extra reach of a super—600 or 800mm—lens may be desired when working with animal species that are wary or dangerous, such as this brown bear below Brooks Falls in Katmai National Park, Alaska. LEN RUE, JR.

In choosing a telephoto lens, it is always wise to check out how close it focuses. When photographing small mammals, such as chipmunks or pikas, a close focus capacity is important. You have to be able to pull the subject in close enough to have a reasonably sized image in the viewfinder yet still maintain sharp focus.

Because of their large size and weight, most telephoto lenses come equipped with their own tripod mounting collars. The camera, which is attached to the back of the lens, is not fastened to anything else unless it has a supplemental leg support attached. Some 80–200mm zoom lenses and 200mm fixed focal length lenses also have tripod collars. Proper balance of your equipment can be maintained by using tripod collars; they also make shooting verticals easy, because the lens barrel rotates in the collar.

In addition to using a good tripod to minimize vibrations when using telephoto lenses, it is important to photograph at a high enough shutter speed for the lens size and the prevailing weather conditions, in order to overcome camera shake. There is an old rule that says you should use a shutter speed that is at least the reciprocal of the focal length of your lens. For example, if you are shooting with a 500mm lens, you should

shoot with a shutter speed of 1/500 of a second or faster; a 200mm lens would be shot at 1/250 of a second or faster. I believe that this rule makes more sense when holding some of the smaller telephoto lenses by hand. I have found that, if I am using a sturdy tripod, I can shoot a 600mm lens as slow as 1/125 of a second with good results; under the right conditions, I can occasionally go as low as 1/60 of a second, although I worry about the results when I do.

One final consideration that can affect the quality of your telephoto lens and the price you pay for it is the manufacturer. All the major camera companies produce their own lenses, which usually cost more than those manufactured by the independent lens companies. As a general rule, the camera brand's lenses tend to be more durable, making them better able to withstand the abuse they are exposed to in outdoor photography. However, some of the large independent lens manufacturers, such as Tamron, Tokina, Sigma, and Vivitar, make some good optics that deserve consideration, especially if price is a major concern.

Teleconverters

I would never buy a telephoto lens that did not have top-quality, matched teleconverters to extend its reach. Teleconverters are attched to the back of the lens and consist of a number of optical elements that increase the magnification of the lens by 1.4X, 1.6X, or 2X. The 1.4X and 2X converters are the most common. Each converter increases the focal length of the lens in use by multiplying the lens's focal length by the factor of the converter. For example, a 1.4X teleconverter makes a 300mm f/2.8 lens a 420mm f/4 lens, a 400mm f/3.5 lens becomes a 560mm f/4.5, and a 600mm f/4 lens is turned into an 840mm f/5.6 lens. A 2X converter turns a 300mm f/2.8 lens into a 600mm f/5.6, a 400mm f/3.5 into an 800mm f/6.3, and a 600mm f/4 lens into a 1,200mm f/8 lens. The biggest drawback to converters is that they cut down on the light reaching the film—a full f-stop decrease for the 1.4X converter, and two full f-stops for the 2X converter. Depth of field is also decreased with the use of teleconverters.

When converters are used, they do not affect the closest focusing distance of the lens, which is a great advantage when you are trying to photograph small subjects. For example, suppose you are trying to photograph a chipmunk with a 400mm f/3.5 lens that gives you an 8X magnification and close focuses down to 14 feet. By attaching a 2X teleconverter, you now have an effective 800mm f/6.3 lens with 16X magnification that still close focuses to 14 feet.

All teleconverters slightly degrade the quality of the image—some more so than others. A teleconverter should be purchased only from the same manufacturer that made your lens, so that it matches the optical design of the lens to ensure top performance. Converters not only magnify the image size of the subject but also make more noticeable any optical imperfection that may be present in either the lens or teleconverter; therefore, it pays to stay away from inexpensive, off-brand converters. People sometimes make the mistake of forgetting that, when you increase the magnification of your lens, you have to be much more careful about making sure that the lens is supported sturdily. The detrimental effects of vibration are also magnified with converters.

Over the years, I have used my 1.4X teleconverter extensively, with excellent results. If you own a good one, the image distortion with this size converter is inconsequential. In the past, some 2X converters produced unacceptable image distortion, but the new 2X auto-focus teleconverters, such as the Canon Extender EF2X for the EOS system, have greatly improved designs that produce excellent results.

Extension Rings

Many people think of extension rings only when doing close-up photography, but they can also be useful when working with telephoto lenses. If you want to increase the image size on the film by moving closer to a subject, extension rings placed between the camera and lens let you focus at a shorter distance than the lens normally allows. I always have a set of extension rings with me when I am working in the field. A set consists of rings of varying thicknesses so that you can mix and match them. Using extension rings decreases the amount of light reaching the film.

Mirror Lenses

Mirror, or catadioptric, lenses have the advantage of being small, light, compact, and reasonably priced. The most common focal length is 500mm. The downside to mirror lenses is that they don't have an adjustable aperture ring, which means that you can't change the f-stops. For a 500mm mirror lens, the f-stop is usually a fixed f/8, which is quite slow for a lot of wildlife applications. In addition, a mirror lens makes all light-colored specular highlights in the background appear in the shape of doughnuts. When you need to travel fast and light, however, such as on an extended backpacking trip, these lenses have their place.

Zoom vs. Focal Length Lenses

Because of major technological improvements in lens glass, new computer-aided optical formulas, and better materials, the optical quality and performance of today's top-quality zoom lenses are every bit as good as that of fixed focal length lenses. Because of their complex optical designs, zooms have more internal lens elements than fixed lenses, which means that they tend to be heavier, and their maximum f number is still usually a little slower than what is commonly found on fixed focal length lenses. Nevertheless, the ability to quickly zoom in and out and change composition is a highly desirable feature.

Two of my all-time favorite zoom lenses for mammal photography are the 80–200mm ED f/2.8 and the 200–400mm f/4 ED zoom. The 80–200mm lens is the ideal range for many animals that can be photographed relatively close. Today, most top zooms in this focal length range have a maximum f-stop of 2.8. Many also have apochromatic (APO) glass for the finest optical performance possible. Zoom lenses in this range, which include the 70–210mm zooms, are also available in slower maximum f-stops with regular optical glass. Chromatic aberration is not as big a problem in shorter focal length lenses such as these, and if you can live with the slower speed, you can purchase good-quality lenses that are quite inexpensive.

Additional money can be saved if you buy a zoom that has a floating maximum aperture, which means that the speed of the lens decreases as you zoom from wide angle to telephoto. This is common in zoom lenses that have very wide zoom ranges. For example, Canon has a 35–350mm L zoom that has a maximum speed of f/3.5 at the 35mm setting and a maximum speed of f/5.6 at the 350mm setting.

Over the years, a number of lens manufacturers have made long telephoto zooms that work well for wildlife photography. There are a wide variety of zoom lenses available that zoom up to 300 mm, with 50–300mm, 75–300mm, and 100–300mm being the most common ranges. Most of these zoom lenses are compact and light and can be hand held. Two of the best telephoto zoom lenses ever made for wildlife work are the Nikon 200–400mm f/4 ED and the Canon 150–600mm f/5.6. Tokina offers a 150–500mm APO f/5.6, and Nikon has a 180–600mm f/8 ED zoom. Two new lenses also deserve mention: Tamron's AF 200–400mm

f/5.6 LD (IF)—indicating low-dispersion optical glass and internal focusing—is autofocus compatible with Canon, Nikon, and Minolta cameras. Also available is Pentax's AF 250–600mm f/5.6 ED (extra-low-dispersion glass) with power zoom.

Zoom lenses are invaluable when you are forced to photograph from a stationary position, such as when working out of a photographic blind or when working with controlled animals at a game park or zoo, where you have absolutely no control over how close you can get to an animal subject.

Macro Lenses

Macro or close-focusing lenses are optically designed to focus closer to a subject than is possible with normal lenses of comparable focal length. Most macro lenses provide reproduction ratios of 1 to 2 (image size on film is half life-size); a ratio of 1 to 1 (image size on film is life-size) can be achieved with a special extension ring. Some new macro lens designs offer 1 to 1 reproduction ratios without an extension ring.

Macro lenses come in three focal lengths: normal (50, 55, 60mm), moderate telephoto (100, 105mm), and 200mm. For mammal photography, the 200mm macro is the most practical for photographing smaller subjects, and the 100 or 105mm can be useful for photographing animals under controlled conditions, especially for close-up head shots.

Supports
Len Rue, Jr.

Tripods

No one wants to have to carry one around, but after the camera, lenses, and film, a decent tripod is probably the most important photographic accessory you can purchase. Most mammal photography is done with telephoto lenses, and the bigger the lens, the sturdier the tripod must be in

order to provide adequate support. Although I often hand hold lenses smaller than 200mm, the performance of even small lenses can be improved by using a tripod. For example, if you are shooting a scenic view with a wide-angle lens, the use of a tripod permits you to select a smaller aperture opening to increase the depth of field because you can use a slower shutter speed. A secondary benefit is that the use of a tripod slows you down and may encourage you to take more care in composing the scene.

Large telephoto lenses magnify not only the size of the subject but also the effects of every bounce, jar, or vibration. When shooting in the outdoors, there always seems to be a wind buffeting your equipment and causing camera vibration. Also, body movement is transferred through your hands to your camera and lens as you touch them to focus, depress the shutter button, and so on. What is required is a tripod that is substantial enough to securely hold your equipment and to neutralize camera shake. It is important to choose a tripod that is large enough to secure the largest lens that you own; this guarantees that you will also have adequate support for all your smaller lenses.

Another important criterion when purchasing a tripod is its effective range, from its lowest working height to its highest working height. It is prudent to select a tripod that can be raised higher than your own height in case you need to shoot from a higher vantage point or over some obstacle. In most situations, it is best to photograph an animal subject at its own eye level, so when the subject is small, it is important to have a tripod with leg-spreading capability that allows it to go low to the ground. Some tripods have long, removable center columns that can be replaced with either short center columns ($4^1/2$ to 5 inches) or flat platforms that allow the cen-

ter of the tripod to be lowered right onto the ground.

Good tripods are expensive, and the larger they are, the more they cost. But it is foolish to try to economize by purchasing an inexpensive tripod that is inadequate. It is disappointing to spend thousands of dollars on camera equipment and then not be able to take top-quality photographs because your tripod is too lightweight to provide sufficient support.

My favorite tripod is a Gitzo 341, which provides stable support for my 600mm f/4 telephoto lens, which weighs about 14 pounds. Gitzo makes excellent tripods in many sizes and weights that are used by serious amateurs and professionals worldwide. Two other companies that manufacture good-quality tripods in a more moderate price range are Bogen and Slik. One of the most popular models is the Bogen 3221 professional tripod; I would not recommend buying a tripod that is any lighter than this model. Some companies, such as Gitzo, offer tripod models that have four sections in each leg instead of the usual three. The advantage of tripods with four-section legs is that they have a shorter folded length, making them easier to carry in your luggage or in the field. The extra joint in each leg, however, means that it takes a little longer to set the tripod up, and a four-section tripod leg is never quite as strong as a three-section leg.

A unique tripod design is the one incorporated into the Benbo tripod from England. The Benbo tripod is the contortionist king of tripods. Releasing the large center lever releases the center column and all three legs, each of which can swing independently past the horizontal axis. This enables the tripod to be used in almost any terrain, even in locations where a normal tripod can't be set up. The leg tubes are also reversed, with the larger tube at ground level. This tube is sealed to keep out water and mud. My biggest problem with this tripod design is that I always forget that the knob loosens everything, including the legs, and I am afraid that I will forget to hold on to my lens. It also takes a little longer to set up this style tripod.

Tripod Heads

Most higher-grade tripods are sold without any tripod head attached, which gives the photographer the option of choosing the head that is best suited for the particular type of photography. The most common type of tripod head is the studio panorama head, which is operated with three knobs. One knob pivots the platform up and down, the second pivots left and right, and the panorama knob on the bottom rotates the entire head 360 degrees on its base. This type of head allows for precise adjustment, which is ideal for photographing landscapes and still lifes. When photographing moving subjects, such as animals, however, you need a tripod head that enables you to locate your subject in the viewfinder quickly and follow its movements.

The large monoball-type head has proved itself ideal for mammal photography. The main characteristic of this type of tripod head is that it has one large locking knob that, when loosened, enables the ball and the attached equipment to be quickly moved and repositioned in any direction. Most of these ball heads have a tension knob that places pressure on the ball when the large knob is loosened. This helps prevent your equipment from flopping over when the ball is released, and it provides drag on the movement of the ball, which also assists in providing a smooth pan when following a moving animal. The tension knob requires only an occasional adjustment once it is set. The third knob found on most monoballs allows the upper part of the ball head to rotate 360 degrees. This knob is rarely used because loosening the

main knob allows horizontal adjustment of your equipment on the ball head. The large monoballs are $2^1/4$ to $2^1/2$ inches in diameter. The larger the diameter of the ball, the smoother a heavy lens can be pivoted.

Large monoballs are manufactured by Studio Ball, Foba, Bogen, Arca Swiss, Gitzo, and Linhof. The biggest disadvantage of these monoballs is their price. A good, reasonably priced monoball is the Bogen 3038 super monoball head; this head also includes a quick-release mounting plate. Some brands, such as Studio Ball, Foba, and Arca Swiss, are available in either a standard version with a $1/4$-20 threaded stud or a quick-release version with jaws on the top that clamp down and lock onto a universal dovetailed quick-release plate. This plate attaches to the bottom of the tripod collar mounting bracket of the telephoto lens or to the bottom of the camera. Although the quick-release version is a little more expensive and requires the purchase of quick-release plates, it is much more popular than the standard threaded model because of the quickness and ease with which long lenses and other pieces of equipment can be attached. Sometimes the speed with which you can set up your equipment makes the difference between getting a shot before the animal runs off and not getting it.

Another style of tripod head that is made for photographing with big telephoto lenses is the Wimberley tripod head. Other heads, including monoballs, tighten up below the mounting platform, but the Wimberley head's platform is supported on a heavy-duty arm that hangs down from above. The upper pivot point provides vertical movement, and the lower pan pivot provides horizontal movement. The Wimberley head is not designed for general-purpose photography.

Another specialty head for telephoto lenses of 300mm and up is the Four Seasons head. This tripod head also permits free movement by suspending the equipment between two vertical metal supports for up-and-down movement, and it pivots at the base for horizontal movement.

Tripod Accessories

If the wind is strong enough, even a heavy tripod can have trouble holding a big lens steady. Leg supports and weight bags help minimize vibration. A leg support is a two-piece telescoping unit that fastens to one of the tripod legs with a ball joint clamp on one end; the other end has a small ball head that attaches to the bottom of the camera. This stabilizing rod is useful when shooting with telephoto lenses and teleconverters. In this type of setup, the lens is mounted to the tripod with its tripod mounting collar, and the camera and teleconverter are fastened to the back of the lens. A leg support is an excellent way to increase stability, but it works effectively only when it is locked tight. This means that it is effective only for long-range, stationary subjects; it doesn't work well for moving animals. The leg support manufactured by Kirk Enterprises is one of the best on the market.

A weight bag is simply draped over the barrel of a big telephoto lens to dampen vibration. These bags are sometimes sewn with double compartments so that the bag lies over the lens barrel like a saddle on a horse. The bags can be filled with sand or lead shot to add weight. Some tripods come equipped with hooks at the bottom of the center columns from which weight bags can be hung to make the whole tripod more steady.

Another accessory that you should consider is tripod leg covers. These insulated wraps make the metal legs warmer to touch in the winter and cooler in the summer. The insulation layer helps cushion the tripod when it is carried over your shoulder with equipment on it, and they give the outer

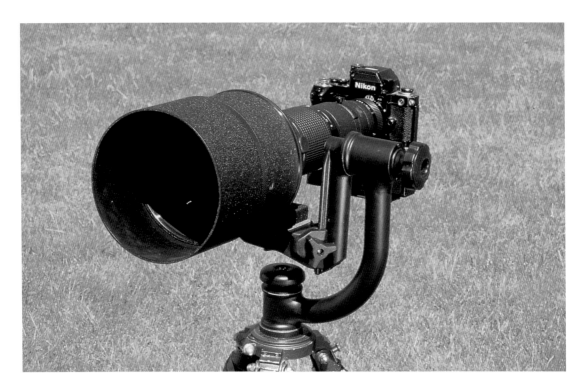

The Wimberley tripod head is ideal for photographing with large super telephoto lenses such as the 600mm f/4 and the 800mm f/5.6. Because the weight of the equipment is supported by an arm from above, it's easy to balance the equipment and pan with a subject while shooting action sequences. LEN RUE, JR.

tube of the legs excellent protection from dents in case the tripod gets knocked over. It doesn't take much of a dent on the outer tube of a tripod leg to prevent the other leg sections from telescoping as they should. Probably the best covers on the market are the Laird Tripads.

Monopods

A monopod is a single tripod leg at the top of which you fasten your camera or lens. The principle behind a monopod is that you brace your equipment against your body and, by adding the monopod to your own two legs, you end up with a tripod, of which you are a part. A monopod can be useful when following an animal in fast

action, and it can be effective when used with a moderate telephoto lens, such as a 300mm. It cannot provide the support of a tripod, however. This is especially true when using long telephoto lenses. Gitzo makes a heavy-duty monopod (model 565) that comes equipped with a built-in shoulder support, which is an improvement over regular monopods.

Shoulder Stocks

There are several brands of shoulder stocks on the market that are made of wood and metal. For telephotos in the 200–300mm range, such stocks work well. I have a 300mm f/2.8 lens, and I have done a lot of good work using this lens with a shoulder

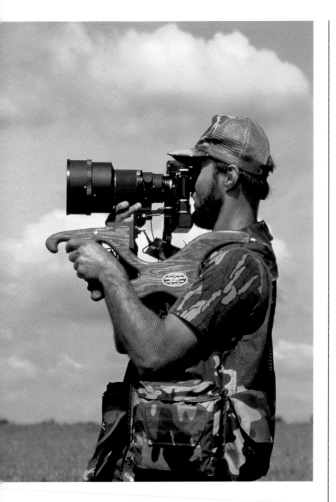

A camera shoulder stock comes in handy when photographing fast-paced action; it allows you to twist your body to pan with a subject that's moving in front of you. This type of support works well with moderate telephoto lenses (up to 300mm). LEONARD LEE RUE III

stock. Because of the vibrations inherent in this type of support, however, you must be able to attain shutter speeds of 1/250 of a second and up to get satisfactory results. (You may be able to shoot at 1/125 of a second if you are exceptionally steady or 1/60 of a second if you lean the stock against a tree.) A shoulder stock is an ideal support

when you are trying to capture fast-paced action on film. This is especially true when the stock is combined with the new auto-focus lenses. Speed of operation can also be increased by the use of an electric release, which triggers the camera from hand grips on the front of the stock.

Window Supports

Often, the best blind for a photographer is a vehicle. In state and national parks, refuges, and preserves, the animals have grown so accustomed to the presence of vehicles that they pay no attention to them. Many of these animals are wary of people on foot, however, and will flee the second a person steps out of a vehicle. Therefore, photographing from a car window is a great way to increase your photographic opportunities. There are basically two types of camera and lens supports for photographing from a vehicle window. The first is a variation of the beanbag, and the second is a window bracket with a tripod head mounted on it. The latter method provides better stability and control of equipment.

A beanbag can be purchased inexpensively, and if you are flying to your destination, you can travel with it empty and fill it when you arrive. Beanbags are used by simply laying them over the windowsill and then setting the lens down on the bag so that it nests in the filler material. One problem with a beanbag is that it often situates the equipment too low; you practically have to be a contortionist to look through the viewfinder. Another problem is that, once the equipment is nestled down into the bag, it is difficult to turn the lens if the subject moves. It is next to impossible to shoot action using a beanbag.

Window mounts are much more versatile, and there are two basic styles to choose from. The first type works by gripping the window glass, which is rolled up about two to three inches. This mount

works well for spotting scopes and lenses of up to 400mm as long as they aren't too heavy. Novoflex and Bushnell are two popular manufacturers of this style bracket. The second style of window mount consists of an upper deck to which a tripod head, such as a large monoball, can be mounted and a lower deck that is hinged to the upper deck in the back. The lower deck swings down and is brought in against the inside of the car door and is locked in place after the upper deck is leveled. The unit fastens to the car with a metal lip in the front of the top deck, which fits between the rubber and the glass or fits over the glass if it is raised about an inch. When the unit is taken off the window and closed so that the two decks are parallel to each other, the mount then becomes an excellent unit for photographing at ground level or from the roof or hood of a vehicle. The best bracket of this type is the multipurpose Groofwin

(which stands for ground-roof-window), available from Leonard Rue Enterprises. As long as the support to which it is fastened is stable, the Groofwin works with a telephoto lens as large as 600mm f/4.

Specialty Clamps

In wildlife photography, there always seems to be a need to fasten cameras, strobe heads, and other paraphernalia to unusual places, requiring more than the normal support devices. One of the best clamp systems is the Super Clamp by Bogen. With jaws that open about 2 1/2 inches, the Super Clamp fastens to any round object, such as a tripod leg, tree branch, railing, fence, or post. Various accessories, such as regular tripod heads, double ball-joint heads, and flexible and rigid arms for extended reach, may be attached to the Super Clamp to meet specialized photographic needs.

Film

Len Rue, Jr.

Many people, when they first start out in photography, shoot negative film to obtain prints. In fact, the color reversal (slide film) share of the total film market is quite small when compared with the color negative–print market.

Print film is more forgiving for the amateur in terms of exposure. When shooting color negative film, the exposure can be off as much as 1 1/2 stops in either direction, and the chances are good that an acceptable print can still be obtained. Also, the ease and convenience of viewing prints

In many parks and refuges, wildlife is accustomed to vehicles, but most animals will run or take flight if you attempt to get out of your car to set up a shot. A window pod can eliminate this problem—the Rue Groofwin Pod is shown here supporting a 400mm lens. LEN RUE, JR.

make them ideal for casual photographers whose main interest is sharing experiences with family and friends. On a professional level, if enlargements are going to be made for sale to the public, a fine-grain slow or medium-speed color negative film is a good choice.

As they gain photographic experience, however, most photographers realize the advantages of switching over to slide films.

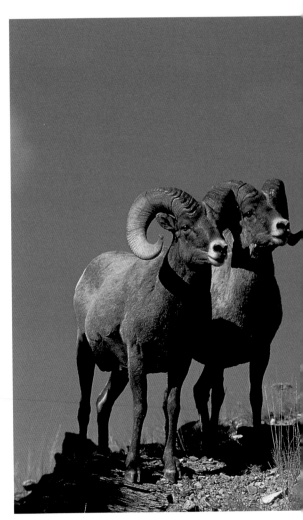

200–400mm telephoto zoom lens, Kodachrome 64 film, 1/250 sec., f/8 (left).
200–400mm telephoto zoom lens, Fuji Velvia film, 1/250 sec., f/6.3 (right).
The left photo of these bighorn sheep rams was exposed on Kodachrome 64, and the right photo was shot on Fuji Velvia. Kodachrome hues tend to be quite realistic; Velvia colors are usually more vibrant. Both photos were shot with a 200–400mm telephoto zoom lens at the maximum setting of 400mm. LEN RUE, JR.

Most serious amateur and professional photographers who are involved in mammal photography shoot color reversal–slide film. There are a number of advantages to this type of film compared with color negative film. The image captured in slide form is much sharper and has greater latitude (the ability to provide more detail in both shadow and highlight areas), and color reproduction is much more vibrant and has better color saturation than can be obtained from print film. For these same reasons, the publishing industry has long demanded that professional photographers who are shooting for reproduction purposes do so with transparency films. One final advantage of shooting transparencies over negative film is that it is less expensive. When photographing with negative film, every frame on the roll is made into a print, regardless of whether it is a good shot. Slides offer you the opportunity to preview them on a light table before you do anything with them. Excellent-quality enlargements, up to 16 by 20, can also be made from 35mm transparency films by having an internegative made, as long as the film original is fine-grained.

ISO/ASA Film Speed Rating

Films are rated in regard to speed, which is based on their sensitivity to light. Each film is assigned a designated ISO/ASA film speed number that tells how slow or fast the film is.

Faster film is desirable when photographing subjects in low light, when there is a need to shoot at high shutter speeds in order to stop action, or when it is necessary to maintain a great depth of field within a scene by closing the aperture on the lens down to a small f-stop. However, there are trade-offs in using faster film. As a general rule, the faster the film speed, the coarser the grain structure of the film, which lowers the image quality. Therefore, it is always

best to shoot with the slowest speed film possible for the subject, lighting conditions, and equipment you are working with.

In the following discussion, references are made to "push" processing. When film speed is pushed, it is exposed with less light than normal by setting the ISO dial on the camera higher than the stated ISO film speed. For example, I occasionally shoot ISO 100 film at ISO 200. When this is done, the development time during processing must also be "pushed" (lengthened) to get the correct exposure. Whenever you need push processing, it is important to inform the lab and let it know at what ISO you exposed the film.

There may be times when you want to increase the ISO slightly (such as from ISO 100 to ISO 125, which is the equivalent of about one-third of an f-stop) to increase the color saturation and give your transparency richer color. When you do this, the lab requires no special instructions.

For over 25 years, the standard color transparency film, against which all others were judged for quality, was Kodachrome 25. The Kodachrome films are processed in K-14, which is a complicated process that only a qualified film processing lab should do. Stored in the dark with proper temperature and humidity control, Kodachrome films retain their true colors far longer than any other type of film. Kodachrome 25 has superior sharpness and fine grain, which makes it ideal for outdoor work that does not require speed, such as landscapes, fall colors, or still lifes. Its slow ISO 25 speed limits this film's use for mammal photography. For almost 20 years, the film of choice of most wildlife photographers was Kodachrome 64. KR64 also has excellent resolving power and fine grain, but its increase of just over a stop in speed makes it better for photographing animals. The color characteristics of the Kodachrome 25 and 64 films tend to be neutral and accu-

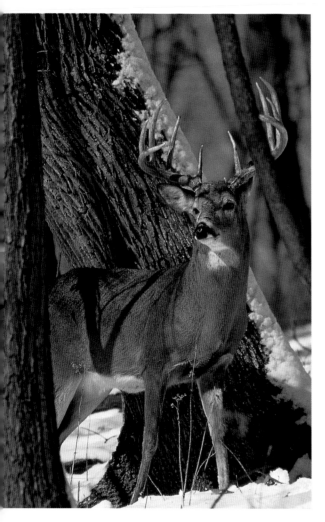 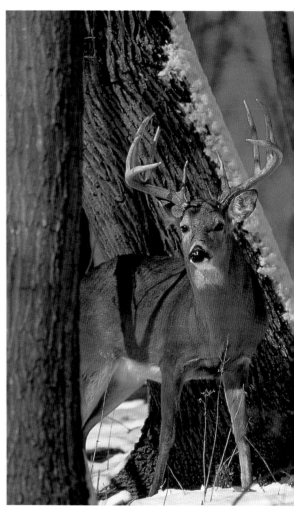

400mm f/3.5 telephoto lens, Kodak Lumiere 100 film, 1/250 sec., f/9 (left).
400mm f/3.5 telephoto lens, Fuji Velvia film, 1/250 sec., f/6.3 (right).
Kodak's Lumiere 100 and Fuji Velvia are both extremely sharp films. The Lumiere (used in the shot of the white-tailed buck on the left) has the advantage of being one stop faster than the Velvia (ISO 50); its color is a bit richer in the brown tones, which can be seen by comparing the tree trunks in both photos. LEN RUE, JR.

rate. Kodachrome is also made in an ISO 200 version that, although sharp, has a coarse structure. Nevertheless, this 200 version is useful for some mammal subjects when added speed is required. The grain of this film can actually enhance some scenes, especially those with snow in them, where the texture of the snow crystals and the film grain complement each other. This film, as well as KR64, can be push processed, although the results are not ideal; push processing is not recommended at all for KR25.

All three speeds of Kodachrome film are available in both amateur and professional versions. The only difference between the amateur and professional films is that the company holds the professional film off the market and lets it age until it will produce the finest color possible.

All films age and eventually go bad, just like food. Most films have about 18 months between the time they are released on the market and their expiration dates. Films slowly shift in color over this time frame. If a film is prematurely released into the marketplace, before it has aged properly, it can have an objectionable greenish or cool color, and if a roll of film is used after its expiration date, the slides can have a magenta or warm cast. If film has 10 to 14 months left before its expiration date, it should give ideal color. If the film is properly stored in a cool, dry place, it should give acceptable color throughout its normal life span. In fact, you can keep film in your refrigerator or freezer if you need long-term storage for a few months. Refrigerated or frozen film must be completely warmed to room temperature before you break the package seal, however, in order to avoid problems with moisture condensation.

In the last three or four years, there has been a drop in the number of photographers shooting Kodachrome 64 in favor of Fuji's Velvia (ISO 50) and the new crop of ISO 100 films (Sensia and Provia by Fuji, and Ektachrome Elite and Lumiere by Kodak). This switch from Kodachrome is mainly the result of the growing popularity of films that give very bright, vibrant colors. All these films are processed in E-6 chemistry, which is offered by most film labs. In fact, E-6 processing is simple enough that it can be done in home darkrooms.

The most heavily color saturated of all the films seems to be Fuji's Velvia. In fact, this film produces colors that are so vibrant that sometimes they are not realistic, but people find the rich colors pleasing. Velvia is in the same league as Kodachrome 25 when it comes to fine grain and sharpness. I have a love-hate relationship with this film. A Velvia blue sky is one of the prettiest blues that I have ever seen, but because Velvia gives a rich warmth to its colors, shooting subjects in early morning light can give slides an excessive golden cast. This film also produces sharp contrasts, which has caused unpleasant results when the sun illuminated my subject with a quartering to side-lit angle. Although this film is rated at ISO 50, I find that I get better results when I shoot at ISO 40.

When viewing a transparency, each individual has his or her own perception as to what constitutes a correct exposure. I tend to look for good color saturation in the sunlit areas of a scene, even if the shadow areas tend to go black. A slide that I think is properly exposed you may think is slightly underexposed (dark). There are differences in personal taste as well as variations in equipment. My suggestions are simply that; they can't take the place of running film tests of your own to see which films you are most comfortable with.

In the mid 1980s, I started shooting Fuji 100 professional film (RDP), which became my film of choice when I needed more speed than Kodachrome 64 could provide. ISO 100 films provide a two-step increase over ISO 25 film. Fujichrome is almost as fine-grained as Kodachrome 64, and I love its rich, warm, natural colors. Although RDP has a slightly warm bias, which makes it ideal for shooting in cloudy, overcast conditions, it also gives good results in full sunlight. The colors are nicely saturated and have a natural appearance. I have shot Fuji 100 and 100 professional at ISO 200 and had it push processed, with excellent results. Looking at the slides on a light table, you would be hard-pressed to tell the normally processed and push processed films apart.

Fuji 100 and 100 professional will probably be phased out soon, because there are now two improved versions of these films on the market. The amateur film, Fuji 100, is being replaced by Sensia, and Fuji 100 professional has become Provia (RDP II). These two films are virtually identical, except that Provia has a slightly higher base density, which is supposed to improve the quality of the separations in reproductions. From my own comparisons of these two films, I have found that the slight difference in base density is meaningless. Even with an eye loupe that goes up to 50X power, I cannot tell the Sensia and Provia apart. They both reproduce and project well. There is, however, an improvement in the sharpness of these two new films over the older Fuji 100 films. The rich, natural color and push processing capability are retained in the new films. There is a substantial price difference between these two films, and I see no rea-

600mm f/4 lens, Kodachrome 64 film, 1/125 sec., f/4.5 (below).
600mm f/4 lens, Fuji 100 professional film, 1/125 sec., f/5.6 (opposite page, top).
600mm f/4 lens, Fuji 100 professional film, 1/125 sec., f/8 (opposite page, bottom).
These white-tailed buck photographs were taken in south Texas. The photo below was exposed on Kodachrome 64, which has very accurate colors. The top photo on the facing page was taken with Fuji 100 professional film, a film with slightly warmer colors. The bottom photo on the facing page was also taken with Fuji 100 professional film but was exposed at ISO 200 and push processed. Although such special processing costs a little more, it can bring about excellent results in sharpness and color. LEN RUE, JR.

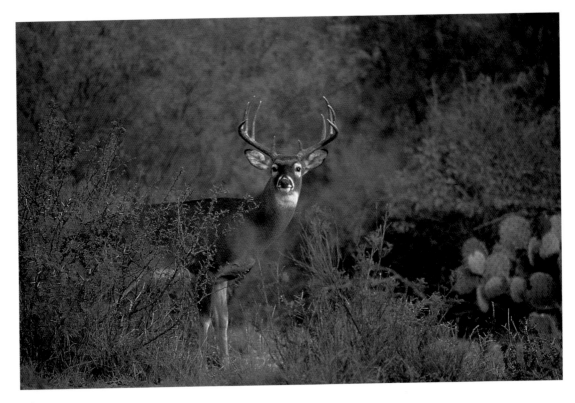

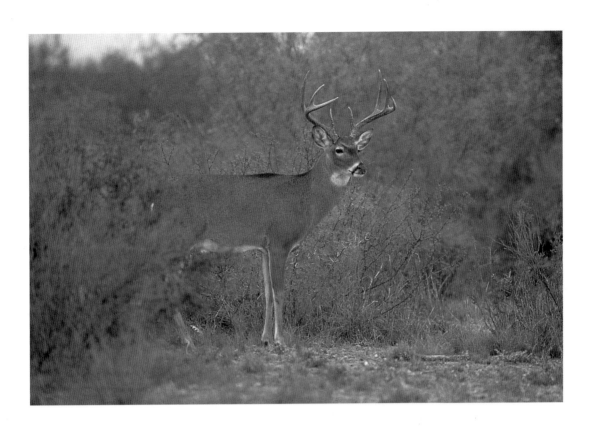

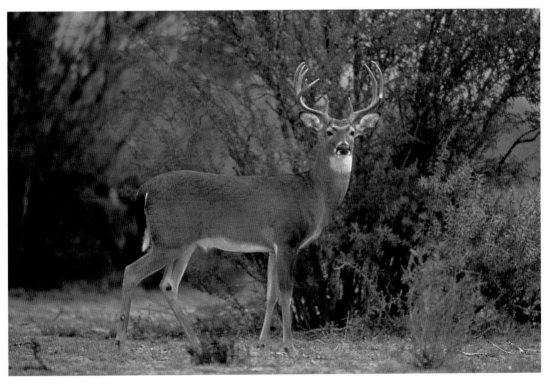

47

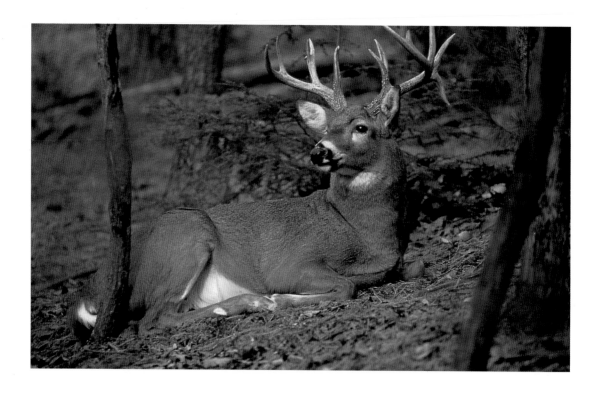

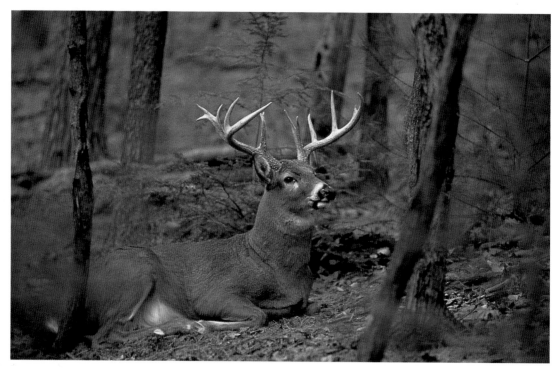

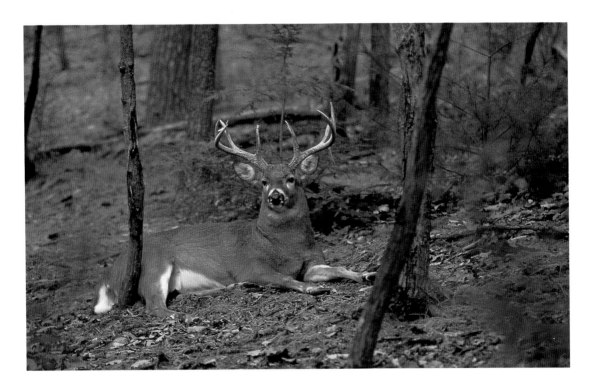

300mm lens, Fuji 100 professional film, 1/125 sec., f/5.6 (opposite page, top).
300mm lens, Fuji Provia film, 1/125 sec., f/5.6 (opposite page, bottom).
300mm lens, Fuji Sensia film, 1/125 sec., f/5.6 (above).
This sequence of three photographs compares Fuji 100 professional film (opposite page, top)
with the new improved Provia (opposite page, bottom) and the amateur version, Sensia
(above). These two new films retain Fuji 100's rich natural colors, but with a definite improve-
ment in sharpness over the original Fuji 100 film. The company states that there is a slight varia-
tion in the thickness of the bases of Provia and Sensia, but I've been unable to detect any
practical difference between the two films. LEN RUE, JR.

son for the average mammal photographer to pay extra for the professional version.

Kodak's answer to Fuji's Sensia and Provia are the two Ektachrome Lumiere professional films (100 and 100X) and the amateur Ektachrome Elite 100. Lumiere is also made in ISO 50 versions (50 and 50X). The film designated with an X is intended for outdoor use and has a warmer color balance that makes it ideal for cloudy, overcast days; the same warm color balance is also satisfactory for use in sunlight. The Lumiere without the X designation has a more neutral color balance that is also well suited for outdoor use, especially if you find the warmth of the X version excessive. Elite also has a warm color balance. All the Lumieres and the Elite are very fine-grained, providing excellent sharpness. My experience with these films has been mixed. I have had good results, but I have also had a few instances in which the warm color balance showed a yellow-brown bias that I did not find pleasing.

49

Although I do not shoot with ISO 200 (I prefer to push ISO 100 film) or ISO 400 film often, these high-speed transparency films are occasionally useful when trying to capture animal action in low light or when shooting with slow lenses. As with the slower-speed films, there has been a major improvement in the quality of high-speed films. Traditionally, serious amateurs and professionals avoided these films because the faster the film, the coarser the grain and the less sharp the image. Nevertheless, it pays to experiment with some of these faster films, because sometimes a fast film makes the difference between getting a great shot and not getting it.

There are two other manufacturers of film that deserve to be mentioned. The 3M company makes Scotchrome brand film in ISO 100, 400, 600, and even 1,000. Agfa makes Agfachrome in ISO 50, 100, 200, and 1,000, with some of these speeds in both amateur and professional versions. Some of these films are excellent for mammal photography and deserve to be tried.

Remember that every film has its own unique characteristics, and what one person finds pleasing may not appeal to someone else. My advice is to try new films as they come onto the market so that you can judge which film or films are best for you. And once that decision has been made, it is in your best interest to experiment with those films so that you can learn what they can do for you. But you must narrow it down to just a couple of films, or you will never master any of them.

Bags, Packs, and More
Len Rue, Jr.

Wildlife photography requires that you have an extensive variety of equipment on hand to meet the unique circumstances of each photographic shoot, and because it is done almost exclusively in the field, you end up having to carry all this equipment around. Telephoto lenses, because of their size and weight, compound the problem. I am always envious of business executives waltzing onto airplanes carrying their little attaché cases, while I struggle aboard with about 50 pounds of camera gear in two bags, one of which I have to somehow store in the limited overhead space.

There are some excellent products on the market today designed to make transporting your equipment, whether on a plane or in the field, a little easier. The objective is to find a carrying system that works for you, is convenient, and protects your gear.

Camera Cases and Bags

Most people start off with camera bags. There are some excellent bags available made by such companies as Tenba, Lowe Pro, Photoflex, and Tamrac, and they come in a wide variety of sizes. Camera bags are excellent for smaller items, such as camera bodies, strobes, lenses up to 80–200mm, and miscellaneous items such as filters, camera releases, film, and extra batteries. A camera bag works for a wildlife photographer if long lenses are transported in separate cases.

Bags usually have one large carrying strap, which tends to cut into the side of your neck or shoulder when the bag is heavily loaded. This means that the bag is often put down on the ground, making it awkward to reach equipment quickly as it is needed.

Soft-sided long lens bags, such as those made by Domke and Tenba, are offered in three sizes to accommodate telephoto lenses from 300mm f/2.8 to 600mm f/4. These bags are made large enough to hold the lens ready to shoot, with the camera body mounted, and they have a large strap for carrying them in the field.

Probably the best protection you can give your equipment is to use camera cases. Camera cases come with either hard or soft sides; some are filled with solid blocks of

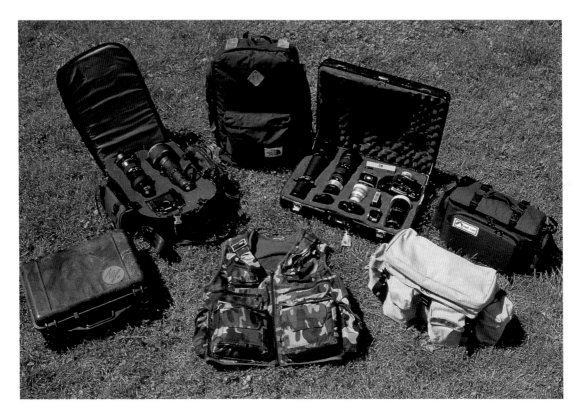

A wide assortment of cases, backpacks, waist packs, bags, and photo vests are available for carrying photo equipment. Pictured here (clockwise from bottom center) are the Rue photo vest, the Pelican waterproof case, the Lowe Pro pack, the North Face rucksack, the Halliburton aluminum case, the Lowe Pro camera bag, and the Tenba camera bag. LEN RUE, JR.

closed cell foam, which you can cut out to fit your specific camera gear; others have cushioned dividers. The problem is that camera cases are instantly recognizable. This invites theft, because people know that they probably contain expensive equipment. One ploy that I have used is to take a regular suitcase (the more beat-up looking, the better), fit it with closed cell foam, and transport camera gear in it. This way, the case is indistinguishable from the 600 other pieces of luggage that may be coming off the conveyor belt at the same time.

Two cases that deserve special mention are the Pelican and Tundra King cases. Con-structed of structural ABS resin, these cases have neoprene O-ring seals and purge valves, making them both water- and air-tight. Packed with high-density foam, these cases provide the ultimate in equipment protection for canoe and raft trips, dry dusty environments, and just about any other harsh climate. In rain forest areas, silica gels can be placed inside these cases for humidity protection.

Now that I've explained the benefits of transporting your gear in cases, it needs to be pointed out that they are inconvenient to work from in the field. It's like walking out into the woods with a suitcase in hand.

Backpacks

Within the last eight years, photo backpacks have become popular with wildlife photographers because they provide a convenient means of transporting equipment, including long lenses. Most of the better packs incorporate proven camping backpack features, such as interior frames, padded harnesses, and hip belts, which make them more comfortable to carry, even when heavily loaded. Some of the best name brands are Lowe Pro, Tenba, Sun Dog, and Tamrac.

The largest, most heavy-duty pack I know of is the Super Trekker by Lowe Pro, which is large enough to carry a 600mm f/4 lens and still have room for other items. This pack is great for toting bulky equipment, but it is not an airline carry-on item.

Lowe Pro's Photo Trekker pack is probably one of the finest camera backpacks made. Lowe Pro is well known for its mountaineering backpacks, and much of that technology is evident in its photo backpacks. The Photo Trekker is large enough to encase a 500mm f/4 lens plus camera bodies and other lenses, yet it fits under an airline seat.

One pack that truly maximizes the small luggage space under an airline seat is the Tenba PBA-K. The PBA-K is eight inches deep and can be filled by placing the equipment on end, which allows the pack to be crammed full of photo equipment. Although this pack comes with a nice belt harness system, the K designation means that it is also equipped with two side flanges, enabling the pack to be fastened to a Kelty pack frame for outdoor excursions.

Sun Dog puts out the Art Wolfe photo backpack, which is well designed and of high quality. One interesting feature of this pack, which comes in two sizes—medium and large—is that there are compartmental lens boxes Velcroed inside—like having a removable camera bag. These lens boxes make for easier lens transportation once you arrive at your destination.

Tamrac is another company with a good reputation that produces a wide assortment of bags and packs. One of the better photo packs in this line is the 787 Super Photo Backpack. It holds several camera bodies and assorted lenses, including a telephoto up to 400mm.

Photo backpacks are great for getting your equipment into the field; however, you have to stop and take them off each time you need to gain access to your equipment.

Vests

For a photo vest to be functional, it must be designed like a wearable camera bag, with everything that you need right at your fingertips. The problem with most of the photo vests on the market today is that they were designed for appearance rather than practicality or usefulness. Many of these vests have poorly designed pockets that don't hold much and provide little protection for equipment.

Nevertheless, I consider the vest an integral part of my equipment, and I use one all the time. When I am shooting out in the field, I am almost always shooting with a telephoto lens set up on a tripod. I wear the Rue photo vest designed by my father, which has over 40 years of experience built into it. While standing behind my large lens with my vest on, I have everything I need within easy reach.

The Rue Vest has 19 pockets total. Each of the two large, padded front pockets has a removable divider and is large enough to hold a big 80–200mm f/2.8 auto-focus lens on one side of the divider and a 105mm macro lens on the other side. I carry those lenses in one front pocket and, in the other, I carry a set of extension tubes, a 1.4X teleconverter, a 24mm wide-angle lens, and a 60mm macro lens.

In the other small front pockets, I carry a

10-foot measuring tape, a 6-foot piece of nylon cord, a 4-by-5 gray card, and lens-cleaning tissues and fluid. The two horizontal pockets in the front hold spare camera batteries, contact cleaners, a lipstick case brush, a small wrench, and a couple of jeweler's screwdrivers.

There are two pockets on the upper front in which I carry a polarizer and 81A warming filters, toilet paper, two predator game calls, and, sometimes, a compact pair of binoculars.

Two inner pockets hold a pair of photographer's gloves and face mask, and the two large pockets over the back hips each carry 25 rolls of film.

The large center back pocket, which opens to the mesh area over the back, holds a full-size folded nylon poncho and a couple of large black garbage bags to put over my big lens in case I get caught out in bad weather.

The mesh back of the vest can be covered over for weather protection with a nylon panel that Velcroes into place. The shoulder areas are padded to make it more comfortable to carry a tripod over your shoulder, and there are built-in camera straps so that you don't have to carry your second camera around your neck.

You can put a lot of equipment in a vest like this, and the weight is evenly distributed over your shoulders, which makes it easy to carry.

Rain Covers

Inclement weather, especially heavy snow, can help create a nice mood in your photographs; however, extra care must be taken to protect your equipment from moisture. A plastic garbage bag is inexpensive and offers some protection but is more effective for snow than for rain.

For more efficient protection, you can use a rain cover made specifically to protect cameras and lenses from the elements. One particularly good choice is the Laird Rain Hood, which is made of waterproof 481-denier nylon. The Laird covers are cut loosely enough to fit a variety of lenses, from the 80–200mm zoom lens all the way up to the 800mm lens, with one of the three sizes (small, medium, and large) available.

When you are on a photo trip, you have no control over the weather, and these covers allow you to get out or stay out and shoot when almost everyone else has called it quits, perhaps enabling you to get the great shot that everyone else missed.

Editing Aids

The sharpness of slides cannot be judged by projecting them onto a screen. The only way to determine whether a slide is sharp is to place it on a light box and view it through an eye loupe with 7X, 8X, or 10X magnification. Although there are several excellent 4X or 5X magnifiers from Germany and Japan, they are not powerful enough to do a good job in judging slide sharpness. I find an 8X eye loupe to be ideal. The 8X achromatic magnifier by Peak is one of my favorites. Moderately priced at around $40, this loupe has satisfactory optical correction, and the field of view covers the entire area of a 35mm transparency at one time.

Slides are also judged for their color, so an important factor to keep in mind when choosing a light box is the color temperature. The light tube, or tubes, inside the light box should give off an ANSI standard 5,000-degree Kelvin light. Uniform light across the top of the box is also an important factor to consider. Small light boxes that hold a sheet of 20 transparencies and contain a single light tube with the correct color temperature are priced around $60. Samigon offers such a box. Another popular brand is Acculight. Acculight offers a single-tube portable model as well as two- and four-foot double light tube models, which are excellent and are reasonably priced for

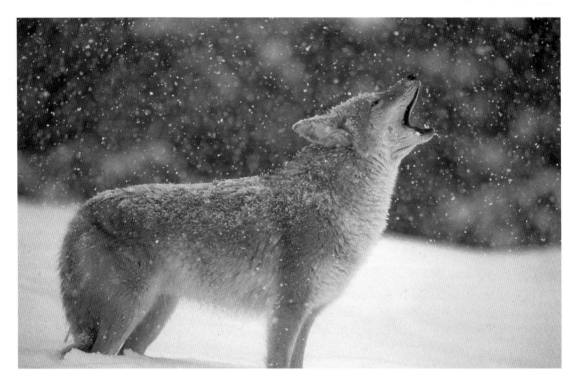

400mm lens, Fuji 100 professional film, 1/125 sec., f/5.6.
Some of the finest, most unusual photographs of animals are taken in inclement weather. In order to photograph this coyote in a heavy snowstorm without damaging our equipment, we used a good rain cover—in this case, the Laird Rain Hood. LEN RUE, JR.

the features they offer. There are a number of good brands of light tables on the market, with some as long as eight feet; these are expensive.

Once we have slides captioned and edited, we have one final step to go through before they are ready for the photo files. Since our transparencies are constantly being submitted, protection is a concern. We insert each individual slide into a slide sleeve to protect it from dust, scratches, and fingerprints. Then, when we submit our work, all our slides (with slide sleeves on) are presented in clear plastic sheets that hold 20 slides per page. It is important to use the archival-type slide sleeves and mounts that are made of polypropylene and

contain no PVCs. PVCs have acids and plasticizers in them, which can damage slides.

Filters

In my general outdoor photographic work, I normally carry polarizing and 81A warming filters to use on smaller lenses when I do landscape photography. I rarely use such filters, however, when I am using my longer lenses for mammal photography. Most of my big telephoto lenses require large filter sizes (122mm or bigger), which makes filters for the front of these lenses very expensive. Nonetheless, because lenses cost much more than filters, I usually place ultraviolet (UV) filters on the front of my large optics, as much for the protection of the

front lens element as anything else. Also, since the telephoto lenses are used to photograph subjects at greater distances, the UV filters help cut haze by reducing blue tones and providing more contrast.

Special Aids to Wildlife Photography
Leonard Lee Rue III

Camouflage
It took years before camera and equipment manufacturers finally realized that not all photographers want their camera equipment to be bright, shiny chrome. The reflective surfaces on chrome cameras reflect the sun's rays as effectively as a mirror and can be seen for miles. While I was working up on a ridge in Alaska, photographing Dall's sheep, I caught flashes of light several ridges away that alerted me to the whereabouts of another photographer. I couldn't actually see the photographer, but I was surely made aware of his presence, as were the sheep.

For years I used to spray all my shiny cameras and equipment with a flat black paint or cover it with black cloth electrical tape. When camouflage tape became available, I switched to that, and I still use it. Today, most equipment comes in anodized black. The few parts or pieces that are still chrome can be painted or taped over. But take careful note of where you set down your equipment in the field; being camouflaged, it may be hard to find.

When doing wildlife photography, I do everything possible to blend in with my surroundings. I always dress in camouflage; even my handkerchief is camouflage. In some cases, the purpose of camouflage is to hide from your animal subjects, but it can also be useful to keep from attracting attention to the wildlife you're photographing.

I use Trebark camouflage clothing, which is the only type treated with the insect repellent Expel. My standard camouflage pants are the army type with big side pockets, which are usually bulging. I always carry insect repellent, perhaps some animal scent, an emergency space blanket in case I need protection from the rain or cold, a granola bar, a soft warm hat, my camouflage gloves, a camouflage or face mask, and toilet paper in a plastic bag.

I don't use the face mask unless I'm working on wary, truly wild birds or animals, and then it is really needed. People don't realize how much light is reflected off light-colored skin. To make matters worse, both my beard and my hair have turned white. I usually wear a mesh baseball-style hat that has a bill and shades my eyes and darkens my face.

I carry two pairs of gloves and use the light camouflage cotton ones to keep off the insects or to ward off the chill of early morning air. When the weather turns cold, I use the same gloves as outerwear and use a pair of warm thermal gloves underneath.

Blinds
The British name for a blind is a "hide," which is really a better name, because that is exactly what you are doing when you use it. Almost all bird photography, and a lot of mammal photography, is done using blinds.

My little company produces and sells two different types of blinds that I designed years ago. The pocket blind folds down to the size of a loaf of bread and weighs about two pounds. It doesn't quite fit in your pocket, but it comes in a cloth bag with straps so that it can be carried on your belt. This blind is used for spur-of-the-moment situations—when you suddenly discover a subject that hasn't yet seen you or you just don't have time to make a larger blind. With the pocket blind, you, your camera, and your tripod become the framework to support the material. You will be much more comfortable using this blind if you have a

stool to sit on. You can sit on the ground, however, provided that your tripod legs are short enough or can be positioned wide enough apart so that you can see through your camera. It is also large enough so that you can stand fully erect in it.

We also have what we call the Ultimate Blind. It is a water-repellent, camouflaged canvas cover over a spring steel frame. It weighs just 9 1/2 pounds. It is the only blind in the world that can be put up and be ready for use in less than 30 seconds and that has no loose parts that can be lost. The blind has two snouts in the front that can be fitted around whatever lenses you are using. Although it is a tight fit, you and a companion can both shoot at the same time. The blind has viewing slots on five sides and slit photo ports that can be used on five sides. The two front panels, under the snouts, have two slit ports that are close to the ground so that you can shoot from ground level, if need be. A good stool (preferably with a back) is a must and should be of tubular construction, with runners on the ground instead of legs, so you don't sink into the soft earth when you sit on it. The Ultimate Blind has a framework on the ground like the spokes of a wheel. You and the stool hold the blind in place if it's not windy. If it is windy, you can stake out the four nylon guy ropes on the outside.

The Rue Ultimate Blind is the only blind that can be put up in 30 seconds or less. Generally speaking, vegetation is greener in eastern North America and browner in the West; the Rue blind comes in green or brown to give photographers a choice in matching their surroundings (although we've found that color is less important than keeping the blind quiet and motionless).
LEN RUE, JR.

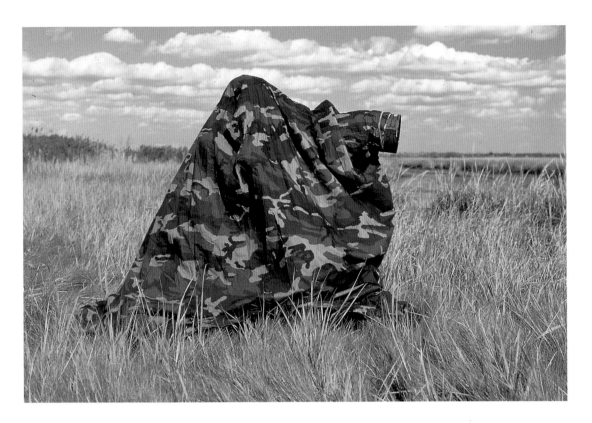

The Rue pocket blind can come in handy when you don't have time to use—or aren't able to carry—the Ultimate Blind. LEN RUE, JR.

If you plan to leave the blind up for a period of time, or if it's exceptionally windy, I suggest that you also use two to four pegs on the struts inside the blind.

Always try to put your blind in front of a tree or bush to break up the silhouette. I suggest using a green blind in the eastern half of the United States and a brown one in the West. More important than color, however, is that the blind does not move or flap. Any blind can be blended into the snow by simply putting a white bedsheet over the top and tying it down; just don't cover the ports.

If you are on private property, you may want to put up a permanent or semipermanent blind; you cannot do this in parks or refuges. The longer a blind is left in place, the more the wildlife becomes accustomed to it, and the more successful you will be. I have a blind on a friend's property that looks like a little outhouse. It has been sitting out there for years. It has vines growing all over it, and I have to cut away the new shoots each year from in front of the shooting slot.

If you are going to be shooting near a cornfield, you can make a framework of poles, tepee fashion, and cover the outside with cornstalks. If you are going to be shooting near a hayfield, pasture, or marsh, you may want to use actual bales of hay to fashion a blind and use a piece of canvas for the roof. Or you can use six-foot-high heavy-

57

duty chicken wire, held in place with four iron fence posts. You can weave grass, hay, cornstalks, or marsh grasses through the wire mesh. Again, use a piece of canvas for the roof.

I worked on many designs for a floating blind but had to give up the idea of putting one on the market because of the tremendous cost of liability insurance. Many people use truck inner tubes or blocks of Styrofoam as the flotation device and then put a piece of plywood, in the shape of a doughnut, over it. They wear chest-high waders and make a sling so that they sit about chest high in the middle of the doughnut. They can then walk around in the pond or paddle about by kicking their feet. I propelled mine with a tiny Minn-Kota electric trolling motor. Over the top, they usually put a framework of wire and cover it with canvas or marsh grasses. It is supposed to look like a muskrat house, and it allows you to get great photographs of ducks, geese, wading birds, muskrat, beavers, moose, and deer. But don't use a floating blind of this type in areas where there are cottonmouth moccasin snakes or alligators.

Although I don't like to photograph wildlife that is below me, sometimes pictures taken from that angle are needed. The sporting magazines are always looking for photos of deer and bears as they would be seen by a hunter using a tree stand. The simplest way to get such photos is to use a hunting-type tree stand. Make sure that you always use a safety belt when using a tree stand, because it's easy to fall asleep after sitting up there for a long time and fall out of the tree.

Some tree stands are self-climbing and are usually used in conjunction with a climbing seat. Another way to get a stand up a tree is to use tree-climbing spurs, similar to those used by linemen to climb power poles. Then you pull the stand up with a rope and secure it. Pole-climbing spurs should not be used for climbing trees, as the spur is too short. Screw-in tree steps are also available, but if you use them, make sure that you unscrew the bottom four or five steps and take them with you when you leave so that no one else can climb up to your stand. Also make sure that your stand is chained and locked to the tree if you plan to leave it in place.

When using a tree stand such as the Screaming Eagle, there is enough space on the platform deck to use a tripod. Because the deck is of open mesh, the points of the tripod legs will not skid, but it is advisable to tie the tripod to the stand so that you don't knock it off.

I have had a Screaming Eagle tree stand locked in place for years on a hillside that overlooks a fox den in the rocks. The stand is on the downhill side, so it raises me just slightly above eye level. I put low, painted plywood panels on three sides of the platform so that I shoot over the top. The foxes have become so used to it that they pay it no attention. I use my camouflage gloves and head mask because my head and hands stick out above the plywood.

A quick-use, disposable blind can be made by spray-painting a cardboard refrigerator carton. The painting is needed mostly to protect the cardboard from moisture, but painting it in camouflage colors also makes it a lot less conspicuous.

In using a blind to do bird photography, either you have to get into the blind when the bird can't see you or you have to have a "go-away" person. When using a "go-away," both of you walk to the blind and then, after you are inside and all set up, the other person goes away. With the exception of crows, birds can't count. They see someone go over to the blind, and they see someone go away. This system doesn't work with animals, however. You have to get into the blind before the animal gets there. For

example, if you know that deer don't become active until 4:30 P.M., you can get into the blind at 3:30. With some other species, you have to get into the blind while it is dark, because if they see you, they won't be back. With some species, such as ground and tree squirrels, woodchucks, marmots, prairie dogs, beavers, muskrat, and nutrias, you can send them scampering into their dens, burrows, or lodges and simply wait for them to come back out.

Be alert to everything that goes on around you while photographing from a blind. On many occasions, I have gotten excellent photos of some other creature that just chanced to walk or fly into the area. The action may be off to the side, so keep watch all around you. Be as quiet as you can in the blind. The blind itself muffles most sounds, even that of your camera clicking, but be conscious of everything you touch or move.

According to the species, the direction of the wind may be more important than the direction of the sun in situating a blind. Although you usually want the sun somewhere behind you, it may be better to have the wind in your favor. Scent is critically important to the canines, felines, bears, and members of the deer family. The other animals, with the exception of beavers, do not pay much attention to it.

Blinds can become unbearably hot in the summer, but all you can do is roll up the flaps to allow some air to pass through. In cold weather, you have to dress warmly if you plan to sit still for long periods of time. I wear heavy thermal long johns, wool trousers, a wool shirt, and a down jacket. On my feet I wear silk or thermal socks, wool socks, and LaCrosse Iceman boots. When walking to the blind, carry your outer clothing so that you don't sweat. Then, when you get to the blind, put on your heavy jacket, overboots, and hat. I carry my icebreaker overboots over my shoepacs

and, with those on my feet and my hat on my head, I can sit in comfort for hours on end and be warm. Being inside the blind also shelters you from the wind.

I have seldom found it necessary, but if you want to raise the temperature in the blind in extremely cold weather, you can light a little can of sterno or use one of those canned candles with three wicks. An old-fashioned kerosene lantern also works well, but all these items give off an odor, and that could be a detriment. The canned candle gives off the least odor.

To help ward off the cold, you should also eat granola bars and candy bars. Hot tea, coffee, hot chocolate, or hot soup is also good, but it's wise not to drink too much liquid when working in a blind. It pays to use the bathroom just before going into the blind and to carry a bottle with you to use during the day. Make sure that the bottle has a watertight top. If the blind is to be used in the same spot, carry the bottle back to the car before emptying it. Another option is to use a Buddy Bag. Although men can use this, it is ideal for women. It comes with an anatomically fitted funnel on top of the bag. When the urine mixes with the contents of the bag, it turns into an almost odor-free jelly that doesn't spill.

Before going out in cold weather, you should coat the eyepiece of your camera with an antifogging solution such as Foggone to prevent your breath from causing condensation on it. No matter how careful you are not to breathe near the eyepiece, just the heat from your body may cause it to fog up. Do not take your camera from a warm, moist room directly into the extreme cold. Cool the camera and lens down first by setting it on the floor near an outside door. When you come back in from outside, set the camera on the floor again, away from the heat, and cover it with your jacket so that it comes to room temperature gradually. This prevents condensation, which

can damage the camera's electrical circuits. In extremely cold weather, it is also important to keep your film warm. Really cold film may shatter like glass. You can carry rolls of film in your pants pockets so that they stay warm by the heat from your legs. You can also carry film in a small insulated bag, along with spare batteries, and put in a packet of Hothands.

Hothands is an odorless packet of natural ingredients that, when crushed, mixes with air and provides heat of about 140 degrees for 7 to 18 hours, depending on the size of the packet. You can slide small packets in your gloves or down the insides of your boots. You can put a large packet inside your shirt in the middle of your back. I often put a small packet in each of my pants pockets or in my jacket pockets and slip my hands in from time to time. You can use big, wide elastic bands to fasten a Hothands to the back of your camera body, helping to keep both the film and the batteries warm. I strap one packet to my video camera's battery, and I drop another along the side of the tape deck.

Scents and Baits

I am a naturalist today because I was a trapper when I was a teenager. During the depression and the war years, it was a major source of my spending money. To be a successful trapper, I had to learn everything I could about the animals, and one of the most important things I learned was to use scent.

Animals live in a world of scent. It is their primary means of communication. We can only surmise the many messages carried by scent. The scent comes from their urine, feces, and glands. Each animal's scent is an individualistic as fingerprints. Animals' sense of smell is thousands of times better than ours, and even our sense of smell is more important than most of us realize. Researchers have proved that our sense of

smell brings back more memories than do any of our other four senses. We respond instinctively to odors that we aren't even aware that we are smelling or reacting to.

Trappers have always used scents, and in the past 20 years or so, hunters have learned to use scents. To be more successful, photographers should learn to use scents too. There are many different kinds of scents. Some are food attractant scents, such as white oak acorn extract. Some are glandular scents from the animals' own scent glands, such as castoreum. Some scents are foreign to the animal but will arouse its curiosity, such as Tonkin musk and anise. Some are sexual attractants, such as urine collected from female animals during their estrous cycles. Some are glandular scents from animals different from the one you are targeting. The beaver gland scent, known as castoreum, is an almost universal attractant to beavers, muskrat, nutria, and all meat eaters.

There are a lot of cover scents, which are designed to mask our human odor by overpowering it. A plain, fresh earth scent is good. Most deer hunters use fox urine because the fox is not an enemy of the deer and it marks the borders of its territory frequently. I don't like to use skunk scent as a cover scent because a skunk does not discharge its scent unless threatened by danger, and other animals know that.

There are also odor-killing soaps and sprays that you can use to minimize the odor of your body and clothing. You cannot eliminate all human odor, however, so always pay close attention to the wind direction when photographing wild animals.

You can buy bottles of scent at sporting goods stores or from trapping magazines. When using scent, use just a few drops; don't douse the area with it.

In national parks, you are not allowed to use bait, as this would be considered feeding the animals, and that's forbidden. Do

not use bait for animals or birds where they can be hunted, because that might be in violation of state or federal law. I put out corn bait for deer, muskrat, ducks, and geese on my private pond, where no hunting is ever allowed.

When using a grain bait, scatter the bait in the high grass or put it in a hollow so that it doesn't show in the photograph. Don't take pictures of deer with kernels of corn stuck to their wet noses. It is always better to photograph the animals coming in to the bait than to do so while they are standing there eating. Putting bait apples under an apple tree is fine, but don't let the apples show in the photograph if the deer is standing in an oak forest. Gather acorns from other areas and put them in the oak forest where you want the deer to be. Or it may be easier just to use acorn scent. Many animals that feed on vegetation cannot be baited when natural foods are available, but scents usually work well year-round.

You can buy canned or bottled bait mixtures from trapping supply houses. These are excellent, and just a teaspoon does the job. Your local supermarket also has excellent bait: sardines. Sardines attract most of the meat-eating animals. They are cheap, readily available, and if you have a few crackers along, you can eat them too. Use sardines that are packed in water or soy oil. Those packed in tomato sauce or mustard won't work.

According to the Automobile Association of America, a million creatures are killed on the highways and byways of the United States every 24 hours. Rabbits and hares are the most frequent victims, with opossums and raccoon being next. Deer are also high on the list. Road-killed rabbits, hares, game birds, and muskrat make excellent bait for any of the meat-eating animals, and they're free for the picking up. Use a pair of rubber gloves, and put the carcass in a plastic bag to prevent getting blood on the inside of your car and to prevent getting contaminating odors on the carcass. Don't bother picking up opossums or raccoon, because none of the other animals will eat them. My home state of New Jersey allows us to pick up dead deer if they are reported to the police or game warden. Many states allow this, but check with your state to make sure you aren't breaking any laws. A deer carcass in cold weather brings in all kinds of animals. A friend of mine in Colorado got excellent bobcat and cougar photographs by using mule deer carcasses.

Calls and Decoys

When I was younger, I spent 17 summers guiding canoe trips into the Canadian wilderness area around the headwaters of the Ottawa River in Quebec. I used to paddle a canoe 1,000 miles each year. I was fortunate to be good friends with an old Algonquin Indian who would stay at our camp all summer. I learned many things from Charlie. He taught me to make a little wooden call using a thin strip of birch bark as a reed. When blown, it made a squeaky sound that he used to call muskrat. He taught me how to make a birch bark megaphone that would amplify the guttural noises we made with our throats in imitation of moose. Calls and decoys have been used by primitive people for as long as recorded history. These people, living with the animals they hunted, became a part of their world.

In our museums are duck decoys made out of reeds and rushes that were used by the West Coast Indians thousands of years ago. In my living room is a duck decoy made out of bound spruce twigs by the Cree Indians of James Bay; they would cover the decoy with the skins of the ducks they were hunting. An early woodcut from the 1600s shows Indians of Virginia sneaking up on deer by covering themselves in the skins and antlers of deer they had previously

killed. George Catlin's famous painting, done in the 1830s, shows Plains Indians stalking close to buffalo covered in wolf skins. All the early mountain men knew that you could decoy antelope to within rifle range by waving a white cloth on a stick. If the wind was in the hunter's favor, the curious antelope would slowly but surely come in closer. All these tricks were first practiced by the Indians and adopted by modern hunters, and they are methods that should be adopted by wildlife photographers.

There are hundreds of wildlife calls available on the market today. If you are interested in photographing deer, you should definitely have a set of rattling antlers and a good grunt call. Although there are lots of imitation antlers available, I recommend that you use a set of real antlers that have been shed or cut off. They don't even have to be a matched pair. You can get them from hunter friends or buy them. Rattling and grunting works best to attract the bucks during the rutting season. There are many good cow elk calls available, and although a bugle call may get a big bull to divulge his whereabouts by bugling back, a cow call is more likely to entice him to come closer.

There are a great many predator calls that work well on all the meat eaters—hawks, owls, and eagles, as well as foxes, coyotes, wolves, bobcats, lynx, cougars, and bears. The various members of the weasel family can also be called in. Most of the predator calls are made to sound like a mouse, rabbit, jackrabbit, or other prey species that has been caught by some other predator and is in its death throes. The incoming predator figures that it just might be big enough to take away whatever was caught from whatever caught it.

I want to insert a word of caution here. Do *not* use a predator call in any area that has grizzly bears, and use extreme caution if there are black bears or cougars in the area. These animals are coming in to get food, and if you move, you might be mistaken for the next meal. Hunters have even had bobcats jump them from behind. It's all a case of mistaken identity, but you don't need that.

Although there are a number of electronic game calls on the market, I use one made by Johnny Stewart. Stewart's screech owl tape is the best attractor I know of for calling in small birds—they try to drive the owl away in the daytime so that it doesn't attack them at night. I prefer using an electronic call whenever possible, because the tapes are made of the actual prey species, and no one can sound as good with a mouth call as the actual animal does. Also, when using an electronic call, I can put the speaker out 50 feet or more from where I'm hidden with my camera, so the predator's attention is focused elsewhere. Volume can be controlled from the blind, and as the predator comes closer, the tape can be turned down or off, forcing the predator to search for the source. When you start to call, play the tape softly so as not to alarm any predator that might be close. Increase the volume every couple of minutes until you spot the predator, then gradually turn the volume down.

While photographing in Texas, my good friend Gerald Stewart, Johnny's son, taught me to put a brown toy "Easter bunny" out as a decoy to be used in conjunction with the electronic call. This gave the coyotes and foxes something to look at, and it helped focus their attention away from me.

The Feather Flex Company has come out with a soft-bodied foam rabbit called Rigor Rabbit. The rabbit is in the standing position and is placed on a battery-operated base that causes the decoy to shake. One model is activated intermittently by a timer. The top-of-the-line model is radio controlled so that you can activate it from a distance.

When using decoys and calls, you will have the best luck on days with no more than a slight breeze. If the wind is strong,

the call will not reach as far. You have to choose a spot that is open enough to give you a chance to take your photographs, but you also need some scattered cover to make the animals feel less exposed. You want the sun behind you, but you have to give top priority to the wind direction, because you basically have to sit facing the wind.

Although most predators dash in quietly from whatever direction they were coming from, suspicious ones circle the call to try to get the scent of whatever is making the sound. The distance between you and the call and the size of the circle the predator makes determine whether the animal passes in front of or behind you. Under those circumstances, using a decoy is invaluable, because if the predator can see something, that will allay its fears and pull it directly to the spot where you want it to be. If a circling predator gets behind you and picks up your scent, it's all over; it will run off.

Although duck and goose decoys have been widely used for hunting and photography for years, animal decoys are just coming into their own. Deer decoys are most widely used, with excellent results. Even though my primary interest is photographing big bucks, I'm always glad to see the first deer—any deer—show up. Having a doe in the area signals to the rest of the deer that the area is safe. The first one acts as a magnet to every other deer. The drawback is that the first deer might detect you and warn the others away. That's where the decoy comes in: it will allay the other deer's fears, but it won't give you away. Liberally

sprinkled with deer scent, it's a super attractant. A great many photos have been taken of bucks either attacking a buck decoy or attempting to copulate with a doe decoy. Using scent, a grunt call, and rattling antlers helps get the deer to come to the decoy area.

The Carry-Lite Company makes an excellent deer decoy that has movable ears and tail. The head and legs are removable and fit inside the hollow body for ease in carrying. The antlers can be removed so that the decoy can be used to represent either a buck or a doe.

The Flambeau Company has just come out with an almost flat folding decoy for both deer and pronghorn. Although it is not as effective as a full-bodied three-dimensional decoy, its ease in carrying is a plus for photographers who are working far from the road. It should be effective with pronghorn, because you can usually see pronghorn from a long distance away and can place the decoy sideways, so that the pronghorn will see the flat side. Pronghorn do not usually circle to get wind of the decoy because they depend more on their eyes than their noses. Both the Carry-Lite and Flambeau decoys have a dull finish to the detailed hair pattern, which is a big plus, because the decoys don't reflect light artificially.

If the things that have been discussed in this section sound like a lot of extra work, just remember that the more effort you put into your photography, the more successful you will be.

Exposure

Len Rue, Jr.

With the continual advancements in computer technology and miniaturization, modern cameras are technological wonders that provide exposure accuracy and control that were unthought of even a few years ago. For example, two Canon camera models, the A2E and the EOS 1n, read 16 different areas in their evaluative metering mode, and Nikon's N90s camera takes distance information from its auto-focus system into consideration when calibrating exposure.

Today's cameras are so good in determining proper exposure that many people have become complacent and simply set their cameras on auto-exposure and let the camera figure everything out. The problem with doing this, however, is that no camera is foolproof. When shooting in the out-of-doors, there are many situations that can fool even the most sophisticated auto-exposure systems. Many times I have envied the control a studio photographer has over lighting and subject. And a landscape photographer exerts some control over the direction, intensity, and quality of light by determining the time of day to take photographs. But for a wildlife photographer, many of those decisions are made by the animal subject.

A wildlife photographer has to learn to make do. The subjects range from black to white, with all shades in between, and the photographer has to be able to calibrate proper exposure without letting it be unduly influenced by backgrounds ranging from the white of glaring snow to dark, heavily wooded areas. Although I have developed a certain amount of expertise regarding how to handle exposure for various lighting conditions and situations while photographing outdoors, a technique that works for me will not necessarily produce exactly the same results for you. Each shooting situation is slightly different, depending on the angle and intensity of the light and other factors, but the following concepts can be used as guidelines.

First, it is important to know the limitations of your equipment. A photographer must understand, upon viewing a scene or subject, when the camera is not going to automatically give the proper exposure so that he or she can override it and set the exposure manually. All exposure meter systems, whether in a camera or in a handheld meter, are calibrated to give proper exposure when reading 18 percent gray, which is the average scene with a lot of midtone ranges in it. Camera manufacturers calibrate this way because the majority of scenes and subjects consist, to a large degree, of midtone values.

If you take an average scene and think of

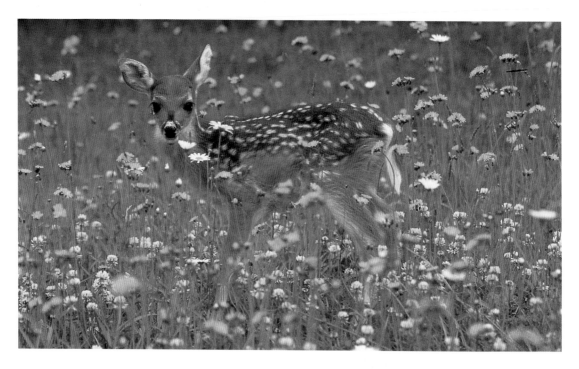

80–200mm zoom lens, Kodachrome 64 film, 1/125 sec., f/5.6.
All exposure meters are calibrated to give proper exposure when the scene is midtone in value or has an 18 percent reflectance. In this scene, both the white-tailed fawn and the spring flowers have midtone values, so no compensation is required. LEN RUE, JR.

it as a black and white photograph, you will notice that you have varying shades of gray tones. In order to differentiate the full range of gray shades, Kodak manufactures an item called the gray scale, which is a horizontal card with gray squares in progression from white to black. In the middle of the scale is a square with an 18 percent reflectance, or 18 percent gray, which corresponds with the midtones in a scene. For example, in nature, the blues, browns, and greens are usually midtones and fall into the middle of the gray scale, which all properly calibrated exposure meters read correctly.

Virtually any camera being run on autoexposure gives good results when the subject and background are midtone in reflectance.

Gray Cards

Gray cards, which come in 4-by-5- and 8-by-10-inch sizes, have a surface of 18 percent gray tone on one side, the same reflectance as the center square on the gray scale; they are pure white on the reverse side. This is an effective, inexpensive exposure aid that you can carry with you into the field. When the card is held in the same light that is falling on your subject, you can take a reflected reading off the gray card. This gives you a fairly accurate reading, regardless of how much light is reflected off the background or subject.

When using a gray card, care must be taken to position the card properly so that it does not reflect excessive glare. The card should be angled about halfway between

600mm lens, Kodachrome 64 film, 1/250 sec., f/5.6.
The exposure of this white-tailed buck stepping out of the shadows was correctly calibrated by using the camera's spot meter to read only the deer, which has a midtone value. LEN RUE, JR.

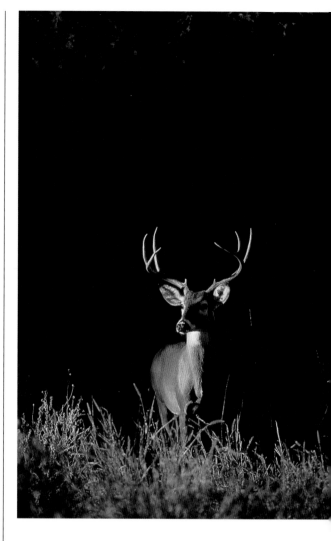

the light source and the camera. If you are setting up your camera equipment in a place that you expect your animal subject to return to, such as a den, you can place a gray card out near where you expect the subject to appear. It is important that the card be close enough to you to fill your viewfinder when using a telephoto lens, or if your camera has a spot metering mode, you can use it to lock onto the card to establish a meter reading. Anything that has an 18 percent reflectance can be used in place of a gray card. For example, the side hair of a white-tailed deer is the equivalent of 18 percent gray, so for years, my father carried a piece of tanned deer hide in his pocket.

If I am faced with a difficult lighting situation, I always look for elements within the scene that are midtone in value and from which I can take a meter reading to calculate the exposure. In dim light situations, you can take a reading from the white side of the gray card and then open the lens up two to two and one-third stops over the exposure called for by the meter reading.

Spot Meters

For years, if you wanted to take spot meter readings, you had to purchase a special hand-held spot meter. Pentax offers a good meter of this type that reads a one-degree spot. Only within the last seven to eight years have certain cameras begun featuring spot meter modes. The spot in most cameras reads about three degrees. In-camera spot metering capability can be useful in many lighting situations. Spot metering allows you to isolate certain values within a scene, such as midtones. For example, if you have a deer, which is midtone in value, stepping out of deep, dark shadows, you can direct the spot meter right on the deer, thus eliminating the black background, which would throw off the reading and cause the transparencies to be overexposed. Because a spot meter reads isolated parts of a scene, care must be taken to make sure that it reads the right part. If elements within a scene that have values

below or above midtone (18 percent reflectance) are read within the spot, improper readings will result. A spot meter can be used to average out a scene by taking readings of the lightest and darkest areas and then splitting the difference.

Incident Meters

An incident meter works by reading the light as it comes directly from the light source, not as it is reflected off the subject and background. This enables you to get an accurate meter reading without any adverse influence by elements that are not midtone in value. A number of companies, including Sekonic, Gossen, and Minolta, make handheld incident meters. Some models, such as Minolta's flash meters, are multipurpose in that they take incident readings of both strobe and ambient light. Some handheld reflected light meters, such as the Gossen SBC, can be converted to take incident readings by placing a diffusion disc in front of the meter's light-gathering receptacle. The meter is then turned around and pointed in the direction of the light source to take the reading.

Light or Snow Scenes

Some of nature's best photo opportunities occur in the winter, so you need to know how to handle scenes with a predominance of white in them. A reflected meter, like the one in your camera, is calibrated to read midtones (18 percent gray). This means that the meter is programmed to assign midtone values to everything it reads. This works fine when the subject or background is midtone, but when it is black or white, the meter has trouble giving a correct exposure reading. It will attempt to make both black subjects and white subjects appear gray or midtoned. There isn't a camera made today that I would trust to provide a satisfactory exposure of a bright snow or

400mm lens, Fuji Velvia film, 1/250 sec., f/11 (opposite page, top).
400mm lens, Fuji Velvia film, 1/250 sec., f/6.3 (opposite page, bottom).
As a general rule, when photographing snowy scenes, it is necessary to override the camera's exposure meter and open the camera's lens aperture one to two stops, depending on the angle and intensity of the light. The whitetail in the top photograph is too dark by about one and a half stops because no compensation was made. The image below shows the proper exposure that results from compensation. LEN RUE, JR.

sand scene without exposure compensation on my part.

When shooting snowy scenes, I run the camera in manual exposure mode. A good rule of thumb is to open up the aperture one to two stops from the meter reading, depending on the direction and intensity of the light source. If you do not override the meter and open up the aperture, your photos will be underexposed, and the snow will appear gray instead of white. In order to make the snow look really white, it may be necessary to open the lens up $2^{1}/_{4}$ stops. But in order to maintain texture and detail in the snow, I usually don't open up more than two stops.

When you have flat, uniform, low-contrast light, as a result of overcast skies, you may find that you don't have to open the aperture up as far. Under such conditions, one to one and a half stops over the meter reading may be enough. If your preference is to shoot on automatic, you can dial in the adjustment on the exposure compensation dial. If you are shooting fairly early in the morning or later in the day, when the light intensity is not as strong, opening up the aperture one to one and a half stops is probably adequate compensation.

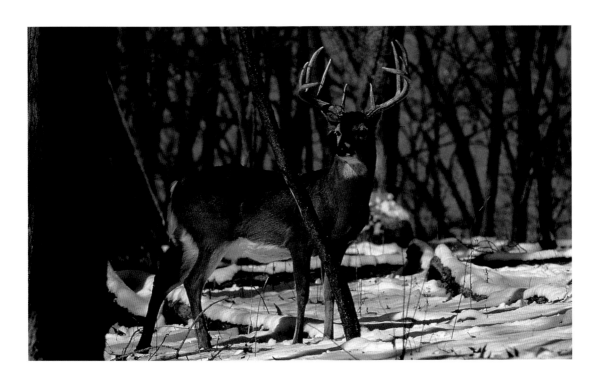

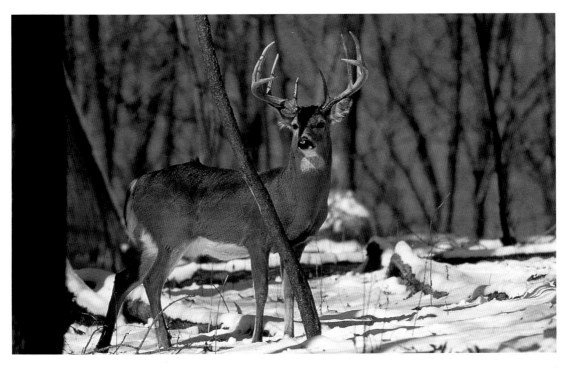

White Subjects or Backgrounds

Photographing animals in snow requires different procedures, depending on what color they are. For example, if there were a brown cottontail rabbit (which is midtone) sitting in a field of snow, I would use the camera spot meter and place the spot right on the side of the rabbit to exclude the surrounding snow, which, if allowed to affect the exposure, would cause the transparency to be underexposed (that is, darker than it should be). If your camera doesn't have a spot meter mode, another handy trick is to zoom all the way in to maximum magnification so that only the rabbit is seen through the viewfinder and read the meter; then, after the exposure is calibrated, zoom back

400mm lens, Fuji 100 professional film, 1/125 sec., f/4.
When photographing white animals on white backgrounds, setting the camera exposure mode on manual and opening the lens aperture one and a half to two stops over the suggested meter reading generally yields satisfactory results. LEN RUE, JR.

to establish the desired composition. For a midtoned subject, such as a cottontail rabbit, use of a gray card would also give proper exposure.

When photographing white animals in snow, you need to open up the lens aperture as much as if you were photographing

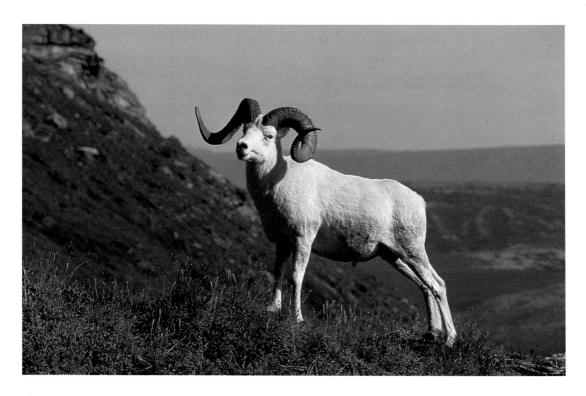

400mm lens, Kodachrome 64 film, 1/250 sec., f/9.
With a white subject on a neutral background, you can achieve the best results by basing the exposure meter reading on the midtone value of the background. LEN RUE, JR.

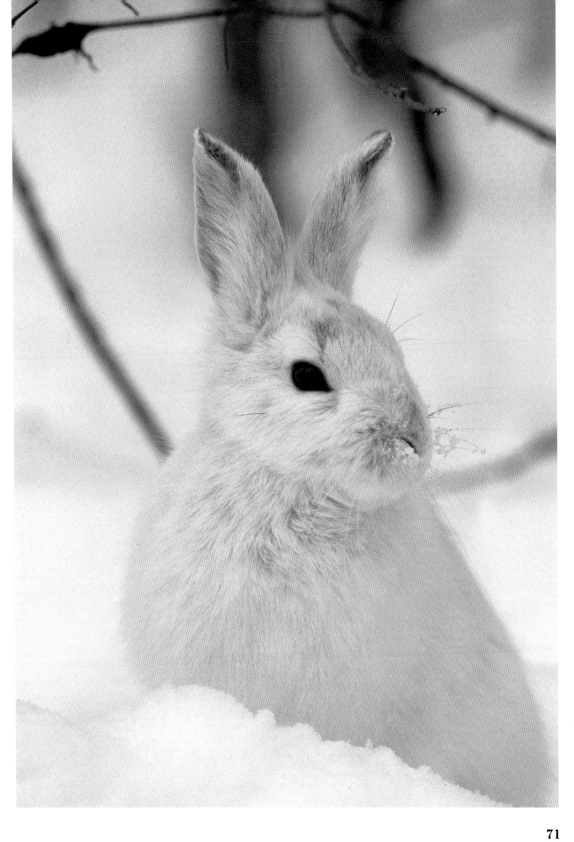

a snow scene. For example, when working with white snowshoe hares in snow, I have found that opening the aperture up two stops from the meter reading produces the best results.

When photographing white subjects against a midtoned background, you can obtain a correct exposure reading several different ways. If your camera is so equipped, you can rely on the spot meter mode; take a spot meter reading directly off the white of the animal itself, and then open up the aperture on the lens two stops. If the background is midtoned, it can be read to establish the basic exposure and then the aperture can be closed one-half to one stop, which will darken (underexpose) the transparency to enhance the texture and detail in the animal's white fur. If a gray card is used to determine exposure, you should also close down the aperture one-half to one stop to compensate for the white of the animal. It may seem confusing, trying to figure out if you should open the lens up or close it down, but it is determined by what you measure for your basic reading. If the reading is based on the white subject, you must open up the aperture one to two stops to make it whiter. If the reading is based on a midtoned background, you need to close down the aperture one-half to one stop to make the subject darker, thus adding detail to the white subject.

400mm lens, Kodachrome 64 film, 1/250 sec., f/5.6.
These two large polar bears were photographed play-fighting at Churchill, Manitoba. In situations like this, where the scene has a mix of light and dark areas, you can include both in the viewfinder and the meter will split the difference to calculate an accurate reading. LEONARD LEE RUE III

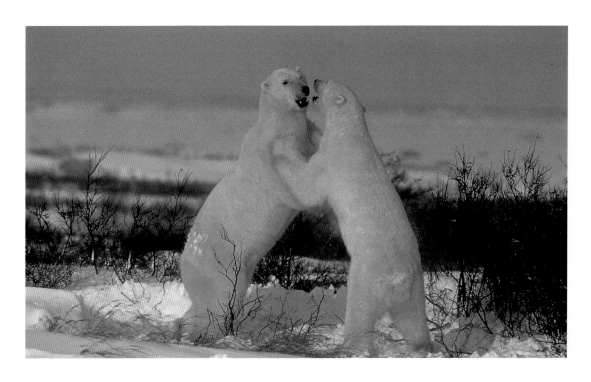

400mm lens, Kodachrome 64 film, 1/250 sec., f/6.3.
When photographing black subjects—such as this young black bear climbing a tree with a neutral background—I base my exposure on the midtones in the scene and then open the lens up one-half stop, which lightens the scene to show more detail in the dark fur.
LEN RUE, JR.

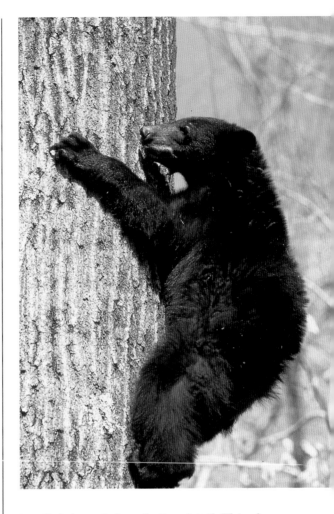

Animals that are light in color, which do not have as much reflectance as white subjects, are handled in the same manner, but you don't change the aperture opening as much. Instead of opening the aperture up two stops, one stop or even one-half stop may be sufficient.

If you have a scene that is predominantly white but with some darker areas, you can sometimes split the difference. For example, when photographing polar bears—which are not really white but an off-white, yellowish color—in an area with scattered dark brush, I obtained good exposure results by swinging the camera over to one of the bushes and splitting the difference by filling half the frame with dark brush and the other half with white snow.

Dark Subjects or Backgrounds
To compensate for dark subjects or black backgrounds, you basically reverse the procedure described for photographing white subjects or white backgrounds.

When a reflected meter reading is taken off a dark subject, it will try to make that subject gray. To compensate for this, you need to close the aperture down. How far you close it depends on how dark the subject is and the intensity of the light hitting it. If you are basing your exposure on a background that has midtone values, however, you have to open up the aperture one-half to one stop; this will lighten up the dark

fur slightly and show better detail. This also holds true when you use a gray card.

As a general rule, when photographing black bears and other large, dark animals such as moose and bison, take the meter reading from the foreground and background areas if they are midtone in value. Then open up the aperture at least one-half stop to lighten the animal.

Backlighting
When you are photographing backlit subjects, the exposure normally requires no compensation or adjustment. The trans-

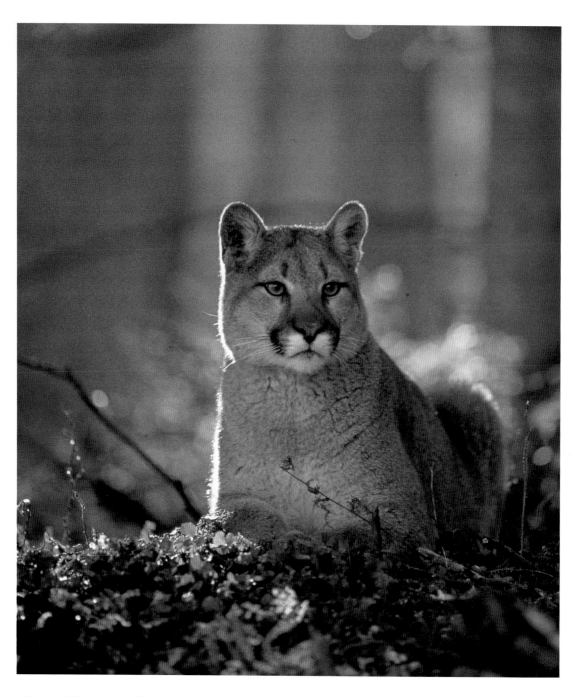

300mm f/2.8 lens, Fuji 100 professional film, 1/125 sec., f/5.6.
With backlit scenes such as this resting cougar, the meter usually provides an accurate reading
without any compensation. LEN RUE, JR.

parencies tend to come out rich and saturated, which makes them ideal for projection purposes. If the transparencies are being shot for publication purposes, with some subjects you may want to "bracket." Bracketing means exposing additional images at one-half stop and one stop over and under the setting that you think is correct. These additional shots are security shots in case you or the equipment miscalculated the exposure.

Silhouettes

One variation of the backlit subject is the silhouette shot. Although most backlit subjects show detail, a silhouetted subject usually shows no detail at all. In a silhouette shot, you show the black shape of your subject, which is usually photographed against sky. In order to obtain the proper exposure for a silhouette shot, such as a deer on a ridge against a sunset, I usually swing the camera left or right from the subject until it is totally out of the frame. Then I point the camera just above the horizon line, where the sky is usually the brightest, and establish that as my main reading. After the exposure is calculated, I swing the camera back onto my subject for proper composition. It is important to remember that only the part of the subject that is above the horizon line and positioned against the plain sky will show up silhouetted in the photograph.

Shooting for the Highlights

As a general rule, on sunny days, when there are both sunlit areas and dark shadows in the scene, always choose the proper exposure for the sunlit areas. Nothing destroys a transparency quicker than having strong sunlit areas that are washed out. Many times, shadow areas that have lost detail are not all that objectionable, providing that they don't interfere with the main center of interest.

When working with sunlight, it is some-times difficult to control excessive and distracting shadow areas. Occasionally, changing the camera position so that the sun is quartering over your shoulder, from behind, helps. If you are working close, with a controlled subject, using a portable reflector to bounce light into the shadowed areas helps reduce a high lighting ratio. Fill flash from a small automatic strobe works well, even with telephoto lenses; it can put a little bit of light into the shadowy areas and some-times even catch a highlight in the eye of the subject.

Today's cameras, with through-the-lens metering, make fill flash a snap. The power of the strobe unit can easily be reduced—so that its light output is about one stop below that which is called for by the ambient light—by dialing in the lighting ratio you desire. This fills in the shadows nicely and lowers the lighting ratio. Care should be taken, however, to make strobe photos as natural looking as possible.

Blue Sky

Having too much sky in the frame when establishing the exposure meter reading can underexpose your photograph by as much as one stop. If I am photographing an animal with a lot of sky in the scene, such as an animal on a ridge, I make it a habit to point the camera downward so that I can take the exposure meter reading off the midtone grasses. Once the exposure is set, I bring the camera back up and recompose.

Sunny 16 Rule

The sunny 16 rule is an exposure metering guide that I sometimes use. Simply stated, this rule says that when it is sunny and the aperture is set at f/16, the shutter speed will be the reciprocal of the stated ISO film speed or a number close to it. For example, if you are shooting a film rated ISO 64 at f/16, the proper shutter speed would be 1/60 of a second. Any other variation of this

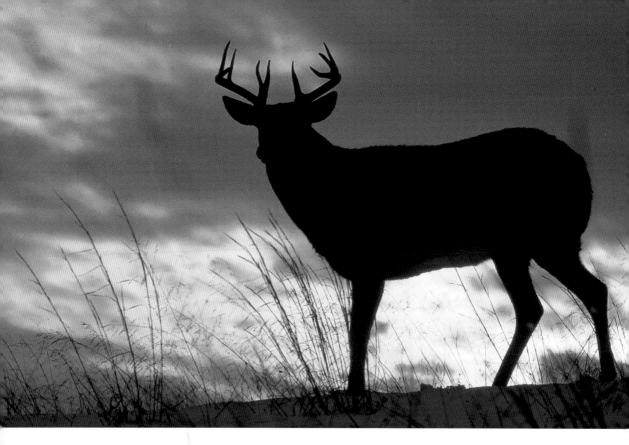

600mm f/4 lens, Kodachrome 64 film, 1/125 sec., f/8.
Exposures for silhouette shots are calculated by swinging the lens off the subject and manually reading the brightest part of the sky, just above the horizon. The camera is then recomposed for proper composition. LEN RUE, JR.

combination, such as 1/125 at f/11, 1/250 at f/8, or 1/500 at f/5.6 would also be correct.

There are limitations to the accuracy of the sunny 16 rule, however. The time of day and the angle and intensity of the sun make a difference, with the rule being most accurate in the middle of the day. Atmospheric conditions also have an effect on the accuracy of the sunny 16 rule. During the warm months in the eastern half of the United States, the sunny 16 rule is off by half a stop. The actual exposure usually calls for one-half stop more light than that called for by the sunny 16 rule. I believe that this discrepancy is caused by high humidity, atmospheric haze, and increased levels of air pollution.

• • •

One of photography's greatest challenges is exposure. In a nutshell, my recommendation is to shoot, shoot, shoot! With experience will come the knowledge that enables you to create more distinctive photographs. Exposure control is the key to mastering light. It can be said that auto-exposure is for ordinary photographs. Many times in the out-of-doors, the best exposure is not what the camera light meter indicates. Many great photographs tend to have unusual lighting as one of their characteristics, whether it be in its direction, intensity, or color temperature. You must be able to work with light and learn how to control it to create or enhance the mood of a scene.

Photographing Wildlife

Photographing the Different Species
Leonard Lee Rue III

Rats, Mice, Voles, and Shrews. The different kinds of rats, mice, voles, and shrews are easily baited and can be photographed in the wild using a flash, as they come out only at night. You can use domestic grains such as wheat and corn, but ground cereal grains such as oatmeal work better. Peanut butter is better yet because of its strong odor.

Most of these small rodents are photographed in setups, however, and there are many types of live traps on the market. The success of your photograph depends on the amount of time and effort you put into creating an authentic-looking background.

Bats. Many people don't like bats, and most people don't photograph them. But bats don't deserve their bad reputations. Bats don't get in your hair, they aren't out to suck your blood (although vampire bats do feed on blood), and only a very small number of them have rabies. Nevertheless, because bats can spread the rabies virus through their urine while flying, going into caves to photograph bats in their natural surroundings can be hazardous if you inhale the vaporized urine.

Most close-up photographs of bats are of

200mm macro lens, Kodachrome 64 film, 1/125 sec., f/9.
Though the mole is quite common, a shot of one digging out of a "push-up" is extremely rare. LEONARD LEE RUE III

captured species, and the specimen is usually handheld. A 200mm macro lens allows you to get good photographs of the bat's head without the person's hands, which are holding the wings, showing.

77

Photographs of free-flying bats in a studio setup require cross-linked electric eyes. To be able to stop the bat in flight requires electronic flash units that have a very short flash duration and a tremendous burst of light for a good depth of field. Such units are not available on the general market.

Tree Squirrels. With the exception of the flying squirrel, all the tree squirrels are strictly diurnal, moving about only during the daylight hours. They are early risers and are active most of the day, with the least amount of activity occurring between about 10:30 A.M. and 3 P.M. They usually retire about half an hour before sunset. I have found that they are active all day long on dark, overcast, or drizzly days, as if they are trying to make up for the later morning light and earlier evening darkness. Unfortunately, such days are not good for photography. In years with a good crop of acorns, walnuts, hickory nuts, beechnuts, and spruce cones, the squirrels are active all day long on even the most beautiful days, giving you great photographic opportunities.

In urban areas where the squirrels are accustomed to people, such as in New York City's Central Park or the local town square, you need a lens of at least 300mm to allow you to stay far enough away to avoid disrupting the squirrel's normal activities. In the wild, you have to work from a blind, as these squirrels can be extremely wary.

Most of them use some sort of natural tree cavity as a denning site if one is available; if not, they construct one out of leaves and shredded bark. Red squirrels almost always use a constructed nest. All the species of tree squirrels store the nuts and cones they gather either singly beneath the forest duff or in an underground cache. You can set up your blind to focus on the den site or concentrate on the squirrels gather-

200–400mm zoom lens with 1.4 teleconverter, Kodachrome 64 film, 1/125 sec., f/9. The heat of midday did not deter this 13-lined ground squirrel from being out and about.
LEONARD LEE RUE III

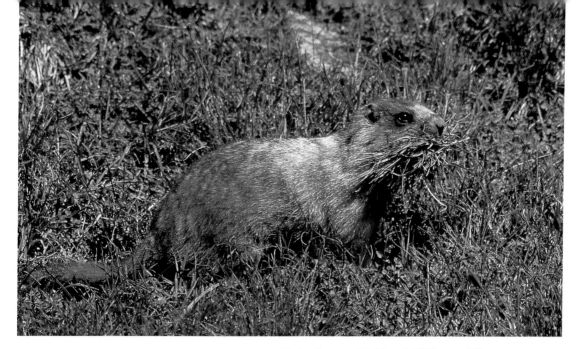

200–400mm zoom lens with 1.4 teleconverter, Kodachrome 64 film, 1/125 sec., f/9.
In late summer, many rodents—like this hoary marmot—gather dry grasses to carry into their
burrows as bedding. USCHI

ing, carrying, and caching nuts. By gathering up the types of nuts the squirrels are caching and scattering them near the den tree, you greatly increase your photographic opportunities, because the squirrels will not have to travel far to find food.

Flying squirrels are strictly nocturnal; they do not come out in the daytime unless they are disturbed. I usually rap with a stick on every dead tree that has an old woodpecker hole in it. If a flying squirrel is living in the hole, it will almost surely pop its head out to see what's causing the disturbance. The only other way to photograph them is to bait them with birdseed, sunflower seeds, or peanut butter. After you have gotten the squirrels accustomed to coming in to feed, you can hide the sunflower seeds in the crevices of the bark of trees so that they won't be seen in the photos.

Regular flash units can be used to get photos of squirrels on tree trunks or feeding. As squirrels are very much creatures of habit, they usually come in to get the bait from the same tree, soar in at the same height, and land in the same spot each evening. To attempt to capture them in "flight," you need the same high-speed flash used for bats and birds.

Ground Squirrels. Ground squirrels, chipmunks, prairie dogs, woodchucks, and marmots all live in dug burrows or rock crevasses. They are all diurnal and are most active from about two hours after dawn until noon. Then, depending on the heat of the day, they retire to the coolness of their burrows until about 4 or 5 P.M. The little 13-lined ground squirrel seems to be able to stand the heat better than the others and is usually active all day.

Most of these rodents are easy to photograph, but it takes time. Any popular picnic area, especially in a park or refuge, is an excellent spot to find them. Wherever there are people eating, these rodents will be there looking for, and getting, a handout. Children find these little critters fascinating, and although it may be against the rules

and regulations, they like to feed them. Almost all the ground squirrels, except the woodchuck and the other marmots, are hoarders, caching food away for use before and after hibernation. Try to get them with their cheek pouches bulging with food that they plan to take back to be cached. Follow them to see where they are storing their food so that you can photograph them coming and going. All the ground and tree squirrels also gather grasses, leaves, or strips of bark to line their nests. Try to get them

gathering vegetation and with their mouths crammed full of it.

Where it is not against the regulations, bait them in with high-quality birdseed. Scatter the seed lightly in the leaves or grass so that it can't be seen. Then you can photograph them as they search for the seeds in exactly the same way they would for natural, wild food. Sunflower seeds make excellent bait, but the seeds are so large that they may be seen in your photo when the squirrels or chipmunks put them in their cheek pouches. Take the time to see what natural foods they are gathering. I got some great photographs of the least chipmunks in Wyoming gathering juniper berries for food.

Set your tripod as low as it will go, or use our Groofwin to enable you to get the ground-level photos of these little creatures that are so appealing. All the ground squirrels and marmots sit up frequently, and some stand up on tiptoe to watch for danger. The tension and alertness they display make for truly great photographs.

Many of the ground squirrels and all the marmots, but not the prairie dogs, hibernate over the winter. The farther north you work, or the higher the elevation, the earlier these animals go into hibernation and the later they come out in the spring. Most come out by late April so that the young they bear will be strong enough to survive hibernation through the winter months. If you want to photograph these rodents, you definitely have to know their hibernation periods. A little-known fact is that chipmunks go into a summer hibernation, known as estivation, for about three weeks during the hottest

200–400mm zoom lens with 1.4 teleconverter, Kodachrome 64 film, 1/125 sec., f/12. We found this female arctic ground squirrel and her young at the mouth of their den, watching for potential danger. USCHI

200–400mm zoom lens with 1.4 teleconverter, Kodachrome 64 film, 1/250 sec., f/6.3.
At the first sign of danger, the black-tailed prairie dog whistles its sharp alarm call. LEN RUE, JR.

part of the summer. They haven't disappeared, they are just escaping the heat.

Opossums and Raccoon. The opossum is strictly nocturnal, and the raccoon is almost so. On dark, overcast days in the fall, a raccoon may come out before dark, but not often. There are some places, such as along the routes of several tour-boat rides in Florida, where raccoon are out in full force during the daylight hours, but only because the people on the boats throw them food as they pass. These animals have become conditioned to being diurnal, but this doesn't happen in the wild. Steer clear of any raccoon you find wandering around in the daytime, because it is probably sick with encephalitis or rabies.

Ringtails, or cacomistles, as they are called in Spanish, are found in the rocks, caves, and crevasses of the mountainous regions of the southwestern states. Their alert, foxlike faces and long ringed tails make them beautiful subjects for photography. Your photos will have to be done with a flash, as the ringtail is strictly nocturnal. They frequent campgrounds and can be baited with any type of meat. Just make sure that you place the meat on a rocky ledge so that it's out of sight and the ringtail is in its natural terrain.

When driving at night, if I see an opossum across the road, I often jump out, grab it by the tail, and bag it to take home. If you try this, be careful, because opossums have a lot of teeth—50 of them—and they don't hesitate to use them. I have the scars of a badly mangled thumb to prove the point. I don't like to livetrap opossums because the

200–400mm zoom lens with 1.4 teleconverter, Kodachrome 64 film, 1/125 sec., f/4. Raccoon usually raise their young in large, hollow tree cavities. LEN RUE, JR.

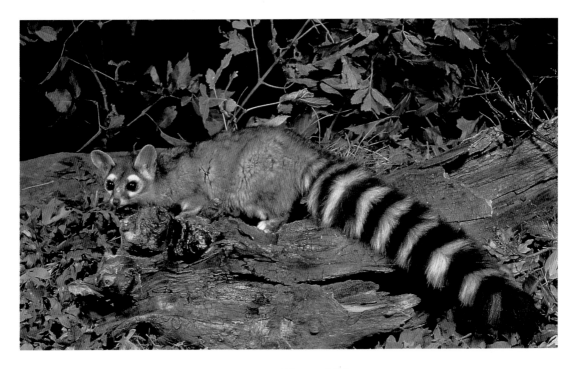

80–200mm zoom lens, Kodachrome 64 film, 1/80 sec., f/11.
I photographed this ringtail, or cacomistle, in a studio—the two highlights in its eyes are the give-
away. My camera was equipped with two flash heads and a Metz unit Pro Pak. LEONARD LEE RUE III

skin above their noses is very thin, and they usually scar it by pushing it through the trap's wire mesh as they try to escape. This will show in your photos. When I photograph an opossum, I put it up a small tree; a big tree won't do, because they scamper to the top, beyond camera range.

I have also raised a number of opossums so that I could do a series of photographs as the young developed in the pouch. They are born 13 days after conception and are about the size of an eraser on a pencil.

55mm macro lens, Kodachrome 64 film, 1/125 sec., f/9.
I took a series of shots of these baby opos-sums as they developed and grew in their mother's pouch. LEONARD LEE RUE III

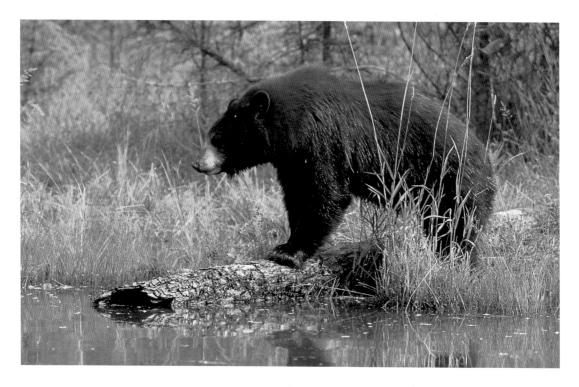

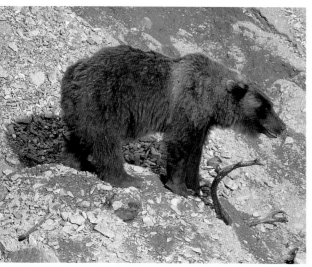

600mm lens with 1.4 teleconverter,
Kodachrome 64 film, 1/250 sec., f/8.
This grizzly bear in Denali National Park has
covered the caribou it just killed to preserve
the meat. LEN RUE, JR.

200–400mm zoom lens with 1.4 telecon-
verter, Kodachrome 64 film, 1/250 sec., f/4.
It took quite a bit of patience to get this shot
of a black bear by the water's edge. Although
black bears have a wider range than any of
the other bears, they don't concentrate in any
particular spot. LEN RUE, JR.

Bears. Pennsylvania has one of the
largest populations of black bears, but they
are found across the North American conti-
nent. The best way to photograph them is
to bait them. The disadvantage of trying to
photograph them where they are hunted is
that they become nocturnal under pressure.

The grizzly bear is a mountain animal
that can sometimes be photographed in Yel-
lowstone and Glacier-Waterton National
Parks. Grizzlies are making a comeback in
both these areas, with Glacier having the
larger population. These bears are usually
photographed from the road, and when

they are found feeding in an area, the word spreads like wildfire through the park. Then all you have to do is to locate the bear jams.

Most of the grizzly bear photos taken today come from Denali National Park in Alaska, where I have seen 18 different bears in one day. Most of the photos are taken by professional photographers who have earned the privilege of being able to drive their cars in the park for 14 days. Almost all the photographs are taken from the road. Amateur photographers have to ride the shuttle buses, and that makes it much more difficult to do good photography.

The two best spots in the world to photograph the big coastal brown bears are the McNeil River and Katmai in Alaska. A lot-

tery system allows only 10 photographers a day on the McNeil, making it next to impossible to get there, but the lottery is open to everyone. The Brooks River campground has just gone on a lottery system, although you can go in as a day-tripper. Because you have to fly to both these locations, it turns out to be an expensive trip. The bears are not aggressive, and the photography is done from regulated viewing areas at comparatively close range. Still, I recommend a 400mm lens.

If you are thinking of photographing polar bears, your best bet is to go to Churchill, Manitoba, during the last two weeks of October or the first week of November. Although the tours are expen-

60mm macro lens, Kodachrome 64 film, 1/250 sec., f/12.
One of the best places to photograph large coastal brown bears like this one is Brooks Falls in Katmai National Park, Alaska. LEN RUE, JR.

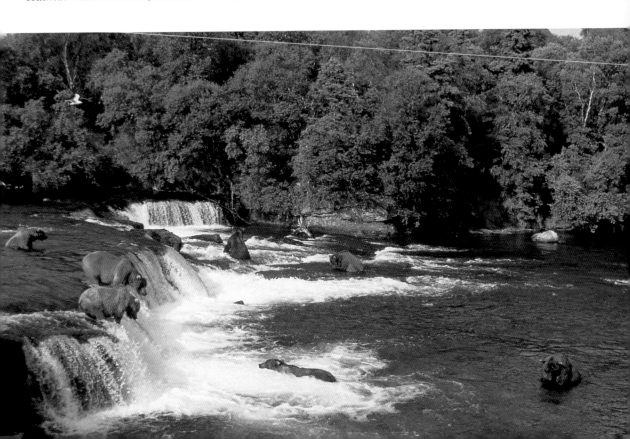

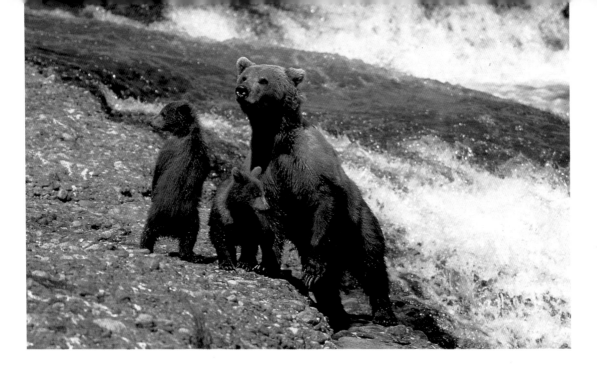

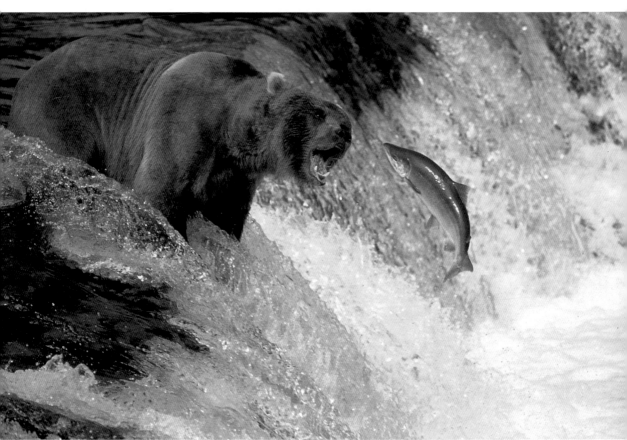

80–200mm zoom lens, Kodachrome 64 film, 1/250 sec., f/6.3.
The raised tail of this striped skunk is a clear warning not to get any closer. LEN RUE, JR.

sive, it is cheaper than trying to arrange the trip on your own. Tour groups are taken out on huge, lumbering "tundra buggies," which are driven right up to the bears. You really wouldn't want to meet a polar bear

200–400mm zoom lens with 1.4 teleconverter, Kodachrome 64 film, 1/250 sec., f/6.3.
The McNeil River in Alaska is home to the world's largest concentration of coastal brown bears. LEN RUE, JR.

200–400mm zoom lens with 1.4 teleconverter, Kodachrome 64 film, 1/500 sec., f/4.
This is a terrific shot, but it wasn't all that difficult to get—in Katmai National Park, the brown bears know just where to stand to have red salmon jump right into their mouths. USCHI

on its own turf in any other fashion. The polar bear is the king of all it surveys, and everything that moves is considered food. On the tour buses, 300, 400, and 500mm lenses are best.

Weasel Family. Skunks are strictly nocturnal but can easily be trapped for photography. You don't have to worry about being sprayed if you use caution and follow these instructions. When I have a skunk in a live trap, I take a piece of canvas or old blanket about four or five feet square. I hold it in front of me as I walk up to the trap, and I talk to the skunk all the time. I don't want it to be surprised. When I get to the trap, I simply put the cloth over the entire trap and tie it with a string or light rope. Then I take the skunk out to a large field, turn it loose, and take some photographs before the skunk lopes off. If you have an assistant,

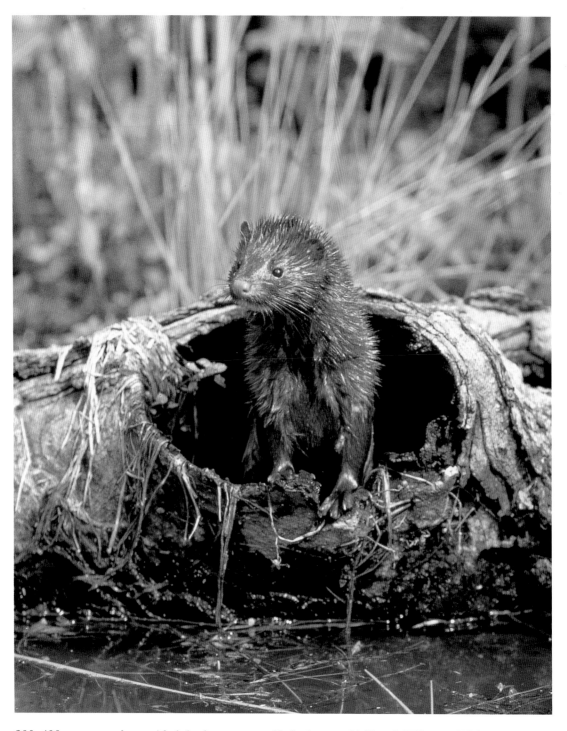

200–400mm zoom lens with 1.4 teleconverter, Kodachrome 64 film, 1/250 sec., f/6.3.
By hunting both on land and in the water, the mink fills the niche between the terrestrial weasel
and the semiaquatic otter. LEONARD LEE RUE III

have him or her get ahead of the skunk, and the skunk will stop and stand its ground, stamp its feet, and threaten with its tail. I have never been sprayed working with skunks in this manner. They really are gentle creatures.

The rest of the weasel family is diurnal—active until midmorning and then active again after 3 P.M. These efficient predators are constantly traveling. Most of them cover their territory following a circuitous route that has them passing a particular spot an average of once every seven to nine days. If they stayed in one spot, they would soon deplete their food supply and be forced to move. They are never numerous, and the chance to photograph them should be considered a special bonus.

Weasels and mink can be found across the continent. Weasels feed primarily on mice but will eat any animal or bird they can kill. I have often seen weasels in the rocky talus slopes while photographing pikas. Many years ago, I found a weasel that had just killed a full-grown cottontail rabbit and was pulling it under an old cabin. I grabbed hold of the rabbit and brought it back out in the open so that I could photograph the weasel. The weasel never let go but screamed in fury. I carried both out, and when I put them down on the ground, the weasel immediately began pulling the carcass to cover again. They are fearless.

Mink are found only where there are streams, ponds, and lakes. Although they prey heavily on mice and birds, they are excellent swimmers and also feed on cray-

200–400mm zoom lens with 1.4 teleconverter, Kodachrome 64 film, 1/125 sec., f/4. The pine marten is found in mountainous areas, a true wilderness animal. LEONARD LEE RUE III

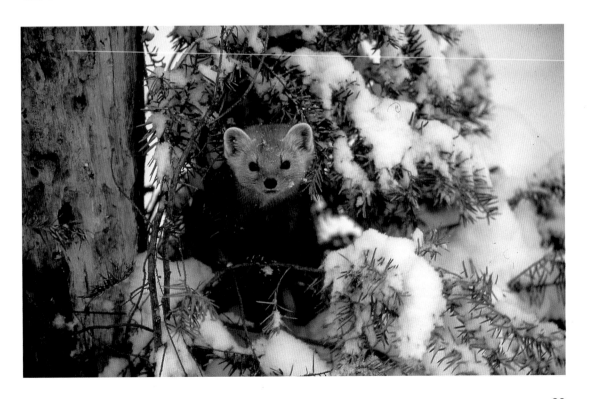

fish, frogs, and fish. Iowa and Louisiana have high mink populations. Mink photos are often taken while photographers are working on ducks or geese.

The various states have done an excellent job of reintroducing the fisher and the marten to almost all the northern states and throughout New England. Even though viable populations exist, both of these animals should be considered rare. I have seen only one fisher in the wild, and although I have seen marten in Alaska, British Columbia, Yellowstone, and the Adirondack Mountains of New York, I have very few photos. The marten have taken to visiting campgrounds in the Adirondacks, where they are often considered a nuisance because they raid the campers' food supplies. They can be baited with meat, but their downfall is blueberry jam. It's the best bait I know of for marten.

The black-footed ferret is an endangered species, and the few areas where they do occur in the wild are off-limits. Adult ferrets are almost strictly nocturnal.

Since the entire country has been working hard to clean our polluted streams and rivers, the river otter has made a tremendous comeback. Many states have reintroduced otters where they had been extirpated. Louisiana probably has the greatest number of river otters, but don't expect to find them on big bodies of water until the weather is cold enough to cause the alligators to den up.

I have done very well photographing

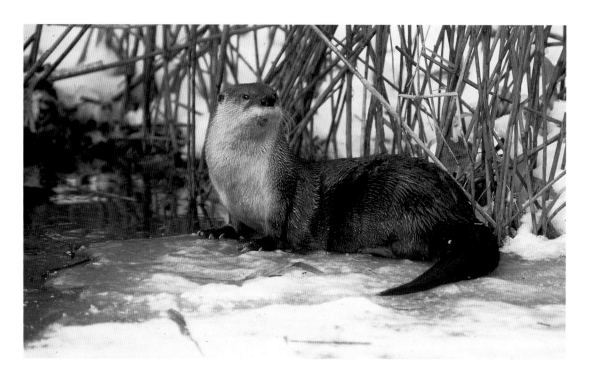

200–400mm zoom lens with 1.4 teleconverter, Kodachrome 64 film, 1/125 sec., f/8.
The river otter can be found anywhere in North America where there is sufficient clean water to support its lifestyle. LEONARD LEE RUE III

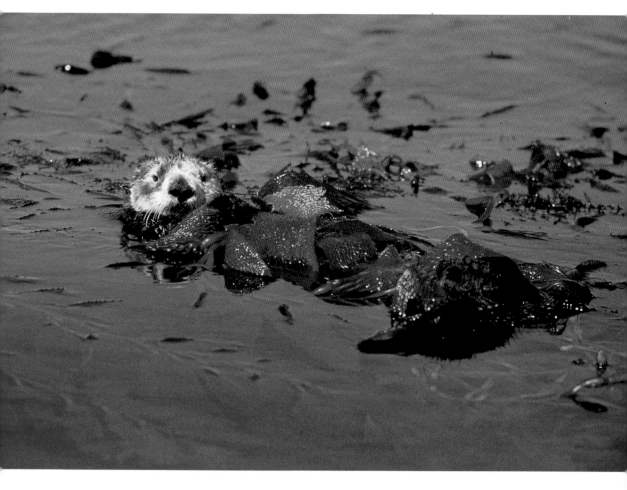

80–200mm zoom lens, Kodachrome 64 film, 1/250 sec., f/9.
The sea otter, although still on the endangered species list, has recovered to the point that thousands now live along the western coast of North America. This one has wrapped itself in kelp.
LEN RUE, JR.

otters in Alaska and Yellowstone, and I have gotten some photos in my home state of New Jersey. They can be baited with fish.

The southern sea otter is an endangered species, but it can be found in many locations along the coast of California, Oregon, and Washington. By law, they are completely protected, but some are shot each year by commercial fishermen. The best place to photograph them is from San Fran-cisco south, at such places as Monterey, Carmel, Pt. Lobos, and Pebble Beach. You need a 600 to 800mm lens to photograph them from the shore, and you are forbidden to get closer than 50 feet if you go by water. They are exceedingly attractive and appealing animals. They sleep by draping themselves with strands of kelp, which helps keep them from drifting out into open water.

Badgers are fairly common and spend part of the day searching for food. They are tough, pugnacious animals, and they have been known to charge at folks who get between them and their burrows. Your best chance of photographing them is while you are photographing prairie dogs or ground squirrels, the badger's main source of food.

In my lifetime, I have seen just five wolverines in the wild and have never had the opportunity to photograph them. Several animal farms have wolverines that you can rent, and most photographs are of captive animals.

Canines. Denali National Park is probably the best spot in the country to photograph red foxes. They come right up to the visitors' center, where they hunt the ground

200–400mm zoom lens with 1.4 teleconverter, Kodachrome 64 film, 1/250 sec., f/6.3. The badger is a powerful animal that feeds on many kinds of ground squirrels. USCHI

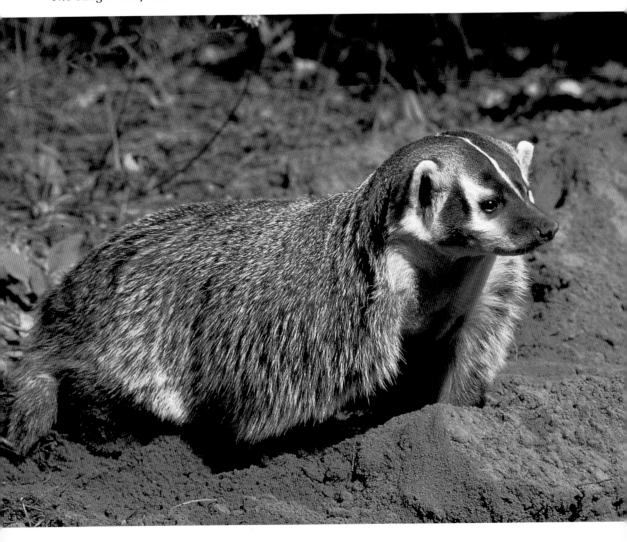

200–400mm zoom lens with 1.4 teleconverter, Kodachrome 64 film, 1/250 sec., f/8. We've never had the chance to photograph a wolverine in the wild; I took this shot at the Triple D Game Farm in Kalispell, Montana. LEN RUE, JR.

200–400mm zoom lens with 1.4 teleconverter, Kodachrome 64 film, 1/250 sec., f/4. This Denali red fox is carrying four arctic ground squirrels back to its den to feed its pups. USCHI

squirrels being fed by the tourists. These foxes can also be photographed along the roads, carrying food back to their dens. I have taken many photos of foxes hunting arctic ground squirrels. Park regulations prevent you from photographing near their dens.

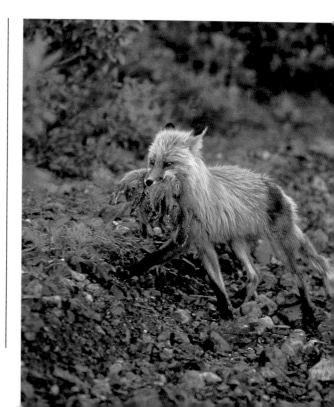

In the midwestern states, such as Illinois and Iowa, you can drive along the road and watch the fields for sleeping red foxes curled up in the snow. Red foxes do not use dens even in winter, unless they absolutely must. Gray foxes use dens year-round, and you have to search among the rocky areas for them. Gray foxes in the West respond readily to calls and decoys.

I have never seen a red fox in Yellowstone National Park because the coyote population is so high. As the eastern coyote has spread throughout the eastern half of the United States, the red fox population has drastically declined there as well. Coyotes don't affect the gray fox population as much because gray foxes stay closer to rocky cover, in which they can escape. The gray fox also has another protection: it is the only member of the dog family that can climb trees.

If you plan to photograph foxes, you should be out in January and February, looking for paired fox tracks in the snow. The foxes pair up in late December and travel and hunt together, and their tracks will lead you to the sites they have selected as maternity dens. The foxes clean out the dens, scattering fresh dirt on top of the snow. After discovering a den, take into consideration the wind and sun direction in order to place your blind in the proper spot. If possible, construct a permanent blind, but do it piecemeal so as not to scare off the foxes. Foxes usually have several

200–400mm zoom lens with 1.4 teleconverter, Kodachrome 64 film, 1/125 sec., f/6.3.
The gray fox is not as numerous as the red fox, and its habitat is much more inaccessible, which makes photographing gray foxes rather difficult. USCHI

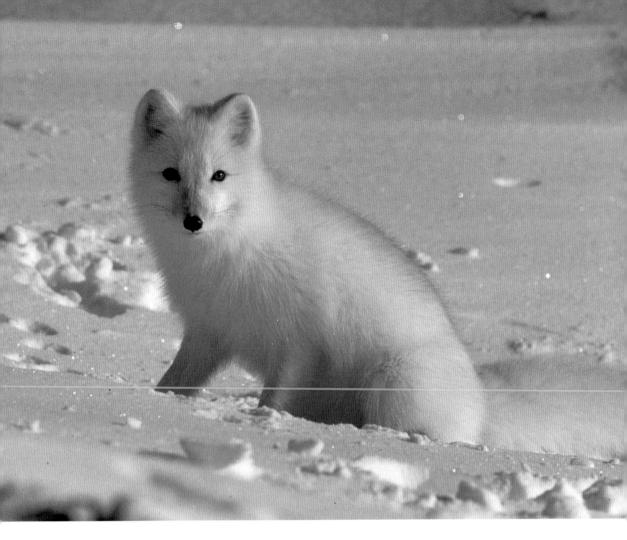

200–400mm zoom lens with 1.4 teleconverter, Kodachrome 64 film, 1/250 sec., f/6.3.
While in the Arctic to photograph polar bears, I was lucky enough to have my camera in hand
when this beautiful arctic fox came by. LEONARD LEE RUE III

dens cleaned, in case they are disturbed and have to move their pups. If you can't find the den but you know that foxes are using the area, put your blind in place and then start to bait it with roadkill.

I have never seen a kit or swift fox, but both of these species are gradually being reintroduced in the western states. Arctic foxes are usually photographed by people going to Churchill, Manitoba, to work on polar bears. They are often photographed in the summer on the Pribilof Islands and

the North Slope of Alaska by people on birding tours. Unless you travel to the Arctic, you are not likely to encounter these beautiful little foxes.

Yellowstone National Park is one of the best places to photograph coyotes. They are common and are very accustomed to people. Most western national parks and refuges have coyotes, but electronic or mouth callers cannot be used. Calls and decoys can be used almost everywhere else in the West and produce lots of good action

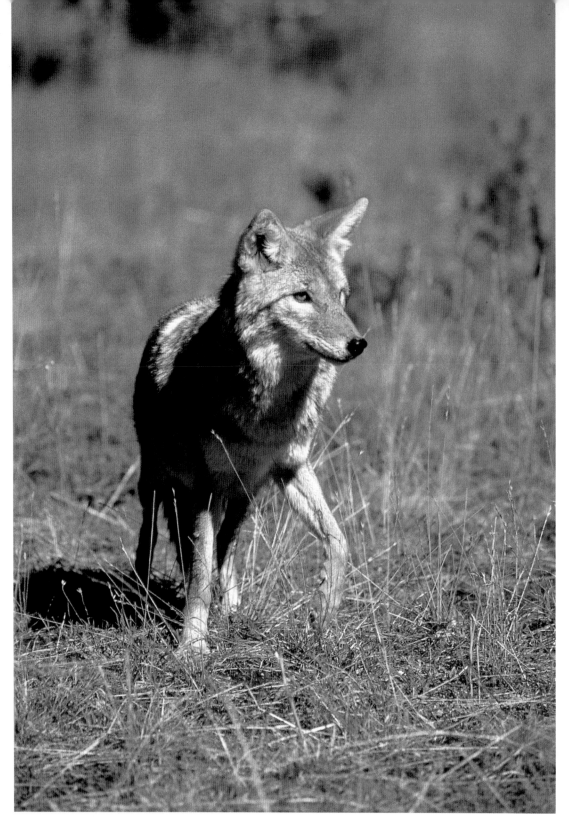

200–400mm zoom lens with 1.4 teleconverter, Kodachrome 64 film, 1/250 sec., f/6.3.
Yellowstone National Park is still the best place to photograph coyotes. LEN RUE, JR.

photographs. The eastern coyote is difficult, if not impossible, to work with. They are extremely wary and do not respond well to calls or decoys. Most coyote photographs have been taken in Yellowstone or are of game farm animals.

Finally, after years of wrangling and a concentrated education program, the wolves have been returned to Yellowstone National Park. This is great news, and it's long overdue. But don't count on getting great photos. If you see any—they have been spotted in Lamar Valley—they will probably be radio collared. You best chance of photographing the wolves in Yellowstone is to do what wildlife photographers have done for years with bears and coyotes. Get into the park as soon as the roads are plowed out in the spring and look for the carcasses of winter-killed elk and bison, identified by ravens circling overhead. These carcasses are large and provide many meals for all the predators and scavengers.

Denali National Park is the best spot in the country to photograph wolves, but even

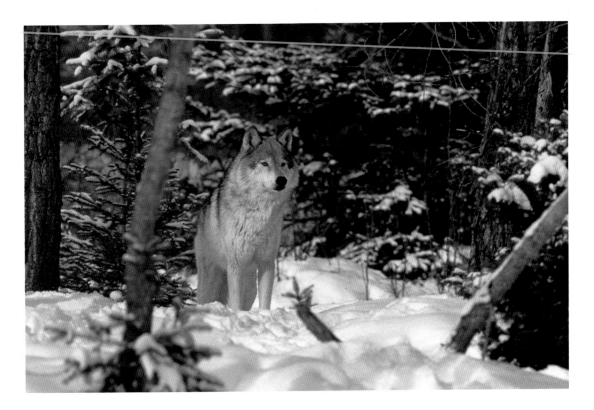

200–400mm zoom lens with 1.4 teleconverter, Kodachrome 64 film, 1/250 sec., f/8.
When photographing game farm animals such as this gray wolf, it's important to capture them against an appropriate background. LEN RUE, JR.

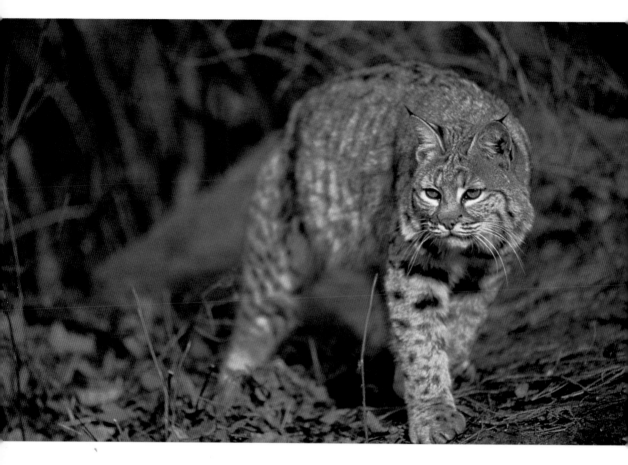

200–400mm zoom lens with 1.4 teleconverter, Kodachrome 64 film, 1/250 sec., f/4. I brought this bobcat close enough to photograph by using a predator call. LEN RUE, JR.

there you will be extremely fortunate to get photographs. Actually, there is no shortage of wolves in either Alaska or Canada. It is estimated that Alaska has over 6,000 wolves and Canada has between 8,000 and 10,000 wolves. There are several hundred wolves in Minnesota, Wisconsin, Montana, and Idaho. Wolves are the very embodiment of the wilderness, and for good reason: they inhabit wilderness areas that put them beyond the reach of the average photographer, including me.

Felines. Almost all photographs of bobcats, lynx, and cougars are of captive animals. Bobcats in the western states come in readily to calls and decoys, however, and they can also be baited with roadkill. In western areas, cougars can be baited too. Many photos show a cougar up a tree, but only after it has been run up the tree by dogs. Lynx are scarce in most areas and do not respond well to either calls or decoys. They, too, are most commonly rented, and only a few animal farms have them.

200–400mm zoom lens, Kodachrome 64 film, 1/125 sec., f/4. The lynx moves through the misty northern forests like a wraith. LEONARD LEE RUE III

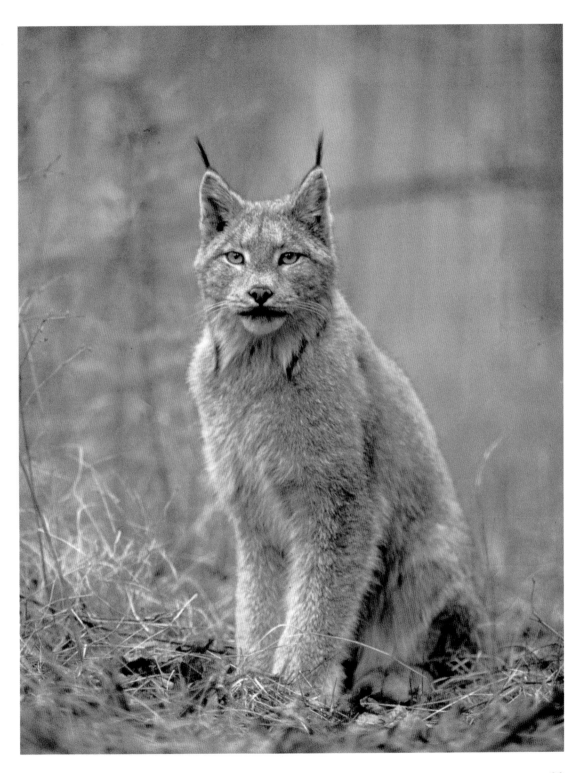

Pinnipeds. The northern sea lion's population is declining, and it may be listed as a threatened species. They are found along the Pacific coast from California north to Alaska's Aleutian Peninsula and Bristol Bay. They are much larger and lighter in color than the California sea lion and are much more wary. They do not bark constantly, as do their smaller cousins. The few photos I have of them were taken from a boat as we circled the rocky islands they frequent off the Alaskan coast.

The California sea lion is occasionally found as far north along the Pacific coast as the state of Washington. It is common along the southern half of the California coast.

200–400mm zoom lens, Kodachrome 64 film, 1/125 sec., f/5.6.
Maurice Hornocker, America's foremost cougar expert, says that he's never seen baby cougars in the wild. This photo was taken of captive animals. LEN RUE, JR.

200–400mm zoom lens with 1.4 teleconverter, Kodachrome 64 film, 1/250 sec., f/6.3.
The sea lion is a common sight along the Pacific coast of North America. LEN RUE, JR.

Seal Rock off San Francisco, despite its name, is world famous for its large sea lion population. The sea lion is a gregarious animal, and they gather in large concentrations. You will probably hear them before you see them. In many areas, sea lions are considered a nuisance, not only because of the large quantities of fish they eat but also

because they have taken over some of the piers. They are strictly protected by the Marine Protection Act, and marina owners are having a difficult time preventing the sea lions from putting them out of business. These sea lions are accustomed to people and will allow you to get quite close. Be careful though, because the large males are occasionally aggressive and can move surprisingly fast, even on land.

The only place to photograph northern fur seals is on the Pribilof Islands out in the Bering Sea off Alaska's west coast. There are a large number of photographic tours to the Pribilofs, where people combine photography of fur seals, sea birds, and arctic foxes. Take the biggest lens you have, because you will need it for all three subjects. A 400mm with a 1.4 teleconverter is the shortest workable lens.

Harbor seals are common off Alaska as well as along both the Atlantic and Pacific coasts of North America. These seals usually feed during high tide, because it brings the fish closer to the shore and into shallower water. When the tide starts to recede, the seals climb up on rocks and rest until the next incoming tide. In areas frequented by many people, the seals are quite tame and allow a close approach. Under all other circumstances, however, they are very wary and will flip off the rocks and be gone before you get within camera range.

Harbor seals are the most common, but the arctic harp seals are probably the most famous because of the publicity they have received. For years, the people of the Canadian coast around the St. Lawrence Islands made a good portion of their living by

200–400mm zoom lens, Kodachrome 64 film, 1/125 sec., f/4.
St. Paul Island in Alaska's Pribilofs is home to the largest concentration of fur seals in the world. LEONARD LEE RUE III

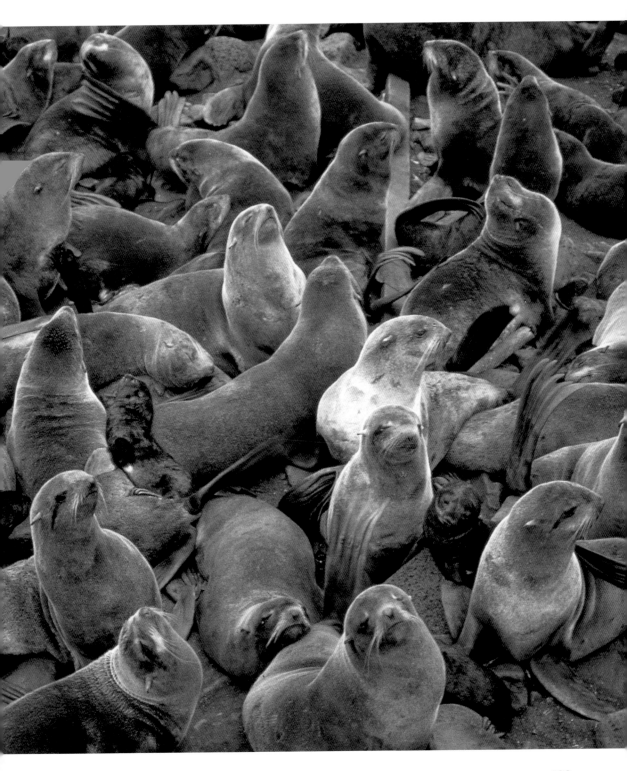

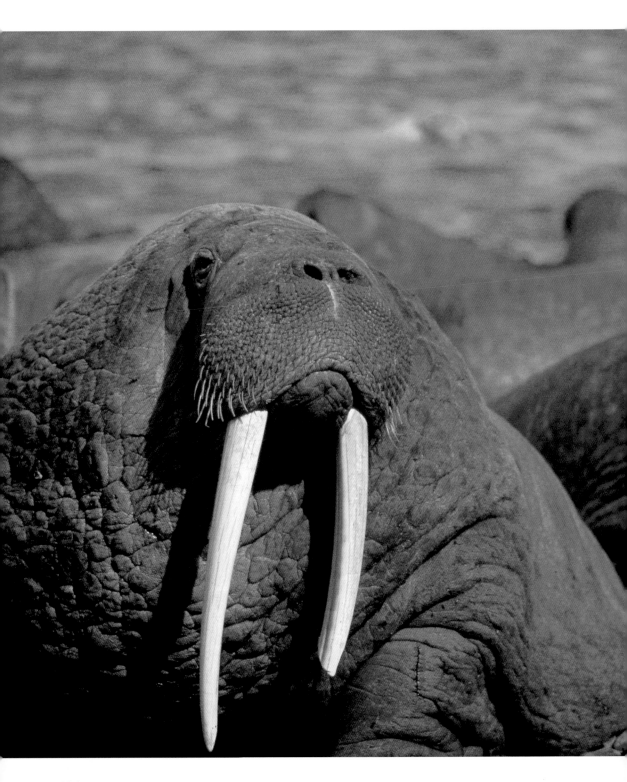

500mm Hasselblad lens, Ektachrome X film, 1/250 sec., f/9.
The best spot for photographing Pacific walrus males is Round Island in Alaska's Bristol Bay. LEONARD LEE RUE III

killing and harvesting newborn harp seal pups, called "white-coats." When the killing scenes were aired worldwide, efforts to stop the hunting were instigated. To help make up for the loss of livelihood, many of the hunters are now employed by the tour groups that take photographers out on the ice to the birthing areas. Helicopters are used to ferry you out, and your time is limited by both the extreme cold and the necessity of not preventing the mother seals from nursing the pups.

Elephant seals are an endangered species found mainly on the beaches and along the coastal islands of Baja California and southern California, although they are found occasionally as far north as the state of Washington. Probably the best spot to photograph them is Channel Islands National Park off the coast of Los Angeles.

The Atlantic walrus is an endangered species, with a population estimated at less than 2,000. Most of the photos of this species are taken in Greenland. There is a much larger population of Pacific walruses, but they are also given complete protection. These walruses can be photographed from a number of islands in the Bering Sea, but the best place to get them on land is Round Island in Alaska's Bristol Bay. This is a state sanctuary, and permission must be obtained from the Alaskan Fish and Game Department in Juneau. The island can be reached by plane from King Salmon or by boat from Dillingham. There are no facilities, and you must camp out and bring all your own food.

On my last trip to Round Island in 1977, the state warden estimated that there were 8,000 big males hauled up on the beach sleeping at low tide. All the photographs of massed walruses that you have seen were taken on this island. When the tide comes in, all the walruses go out to feed, because the rocky beaches are covered with water. As the tide recedes, the walruses bellow constantly as they jostle for a place on the beach to sleep. Although the walruses pose no danger to you, you are no longer allowed down on the beaches. This island is also a good spot to photograph red foxes and sea birds.

Muskrat, Beavers, and Nutrias. Where they are heavily trapped or hunted, muskrat, beavers, and nutrias become almost strictly nocturnal. Where they are protected, they feed and work readily during the daylight hours.

Muskrat can be baited with apples, parsnips, or carrots, but shelled field corn is the cheapest and the easiest to handle, and the muskrat love it. Another advantage to the corn is that when it is thrown into a pond, it sinks and thus does not show in the photographs. I started throwing the corn in my pond to attract wood ducks and Canada geese, but the deer and the muskrat discovered the corn too. Springs that feed the pond keep the area that I bait just about ice-free most of the winter. I put a partially submerged log in the water for the muskrat to sit on while posing for their photos. The muskrat see me frequently, and I talk to them constantly, so I don't need to use a blind to photograph them.

Beavers are crepuscular in my area, returning to their lodges shortly after sunrise and not coming out again until after 6 P.M. In protected areas, they come out much earlier.

A beaver family has to lay up one to two tons of branches and logs, stuck in the mud at the bottom of the pond, as a food supply for the winter. In Alaska, they anchor this supply of food just outside their lodges in

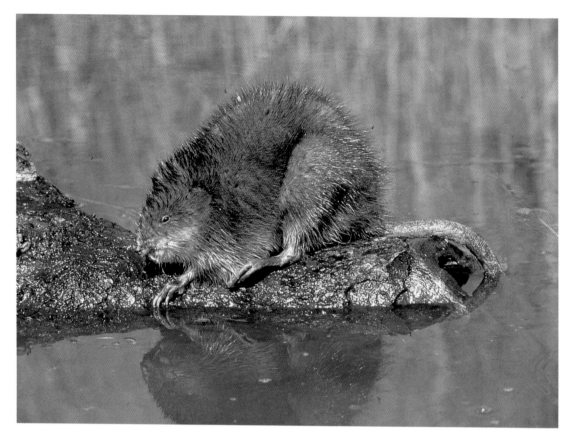

200–400mm zoom lens with 1.4 teleconverter, Kodachrome 64 film, 1/125 sec., f/6.3.
Muskrat can be seen almost all day long in most of the marshes and ponds of North America.
LEONARD LEE RUE III

the month of August. In Canada, they are most active in the last part of August through the first part of September. In the United States, their peak activity occurs during the last half of September and the first half of October. In addition to cutting, hauling, and storing food, beavers are very busy reinforcing their dams and making them higher. They also work to apply generous coatings of sticks and mud to the roofs of their lodges. In the winter, the mud provides an extra layer of insulation, and it freezes to the consistency of concrete, making the lodge impregnable. This period of

extensive activity provides an unending opportunity for photographers.

Beavers can be baited with the same foods used for muskrat, but they don't come to bait as readily, as they usually have an almost unlimited source of natural food. But a few drops of the beaver's own scent, castoreum, will draw them like iron filings to a magnet. Beavers have a very keen sense of smell, so make sure that your blind is placed on the downwind side of where they are working. While photographing beavers, you will probably get the chance to photograph an occasional otter as well.

When photographing beavers, take support photos of their dams, lodges, canals, food supply, and stumps.

Nutrias were imported from South America and escaped into the wild. In Louisiana, they have displaced the muskrat as the number-one furbearer in value. They have also displaced the muskrat physically by usurping its range. The main check on the nutria population is trapping, and alligators and the big saurians work at it all year long.

Like muskrat, nutrias may make and live in holes in an earthen bank. Unlike muskrat, they do not make domed houses out of vegetation. Nutrias make rafts out of floating plant material located beneath dense overhanging vegetation. The bullwhip cane is used for food, for rafts, and for cover. Nutrias are most active for about three hours after dawn and three hours before sunset, although I have seen them out and

600mm f/4 lens with 1.4 teleconverter, Kodachrome 64 film, 1/250 sec., f/5.6
This beaver is chasing a river otter off of its dam. Shots like this can be hard to get; being in the right place at the right time is a big help. LEN RUE, JR.

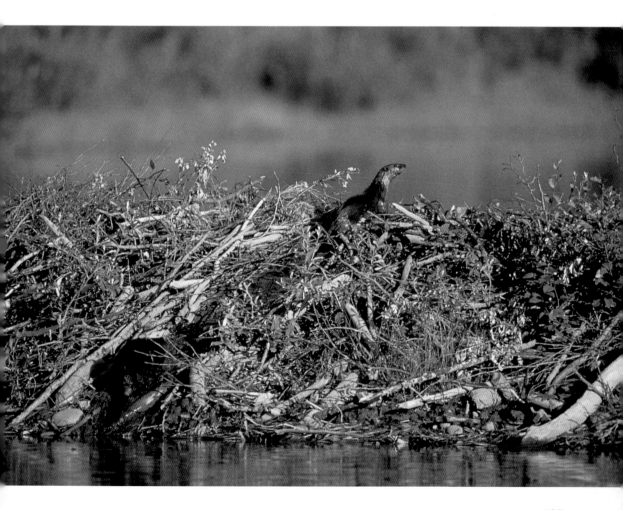

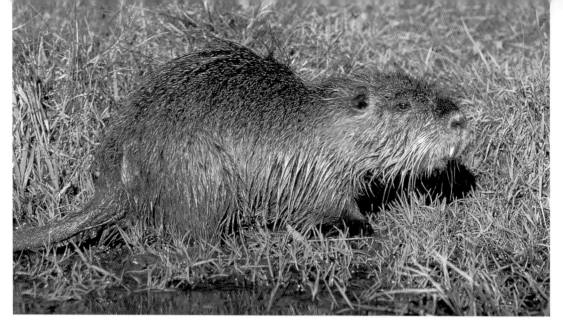

200–400mm zoom lens with 1.4 teleconverter, Kodachrome 64 film, 1/125 sec., f/6.3.
An import from South America, the nutria escaped from captivity and has now displaced the muskrat in most of Louisiana's waters. LEONARD LEE RUE III

200–400mm zoom lens with 1.4 teleconverter, Kodachrome 64 film, 1/250 sec., f/6.3.
All summer long, the pika cuts, dries, and stores vegetation to use as food during the winter months. USCHI

about throughout the day. In the Louisiana refuge, they become quite tame, so you can take frame-filling photos with a 400mm lens, but a 600mm would be better. While working on nutrias, you will also have great opportunities to photograph alligators, egrets, and herons. If you stay in the marshes late enough, the swamp and marsh rabbits may also be out feeding.

Pikas, Rabbits, and Hares. Pikas are probably one of the least known of our wild animals. There are two subspecies that can be found along the mountain ranges that

make up the spine of the western portion of North America. These little "rock rabbits" are only five to six inches in length and are tan to gray in color. I have found them as low as 4,000 feet in elevation and up to 11,000 feet. You will probably hear them long before you see them, as it is hard to locate the source of their chirping alarm call. Their coloring is designed to allow them to blend in with the broken talus slopes they frequent. Pikas are little farmers. All summer long, they cut grass, which they store under rocks to be used for food when deep snow blankets the mountains. These hay piles are quite conspicuous.

There are eight different species of rabbits, and they all look alike except for their size. They can be found in the mountains, the deserts, the swamps, and the grasslands, but none of them inhabit the deep forests. They are active all year long. With the exception of the pygmy rabbit of the Idaho region, rabbits rarely, if ever, dig "rabbit holes." The holes into which they escape, or in which they seek shelter, are made by other animals, such as woodchucks. Rabbits are comparatively easy to photograph if you use a long lens and move very slowly. Rabbits hate to get wet, so the best time to photograph them is after a

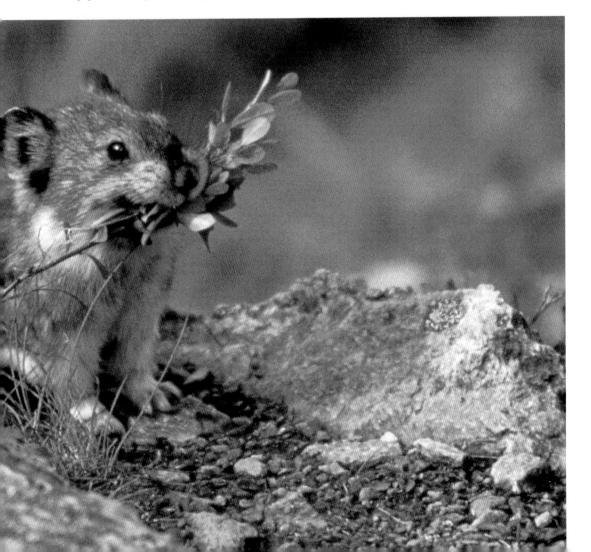

night of rain or heavy dew. On such mornings, rabbits feed in the open rather than in areas where the cover is water laden. All year long, rabbits sit out in "forms." These are areas in high grass or under vegetation where it is hard to see them. They sit there and soak up the sunshine and are protected from the wind. You can recognize a form by the bare earth, which shows where the rabbits sit. Finding a form assures you of getting photos.

There are either three or four species of hares, depending on whether you lump the tundra hare with the arctic hare. The European hare is an import. They have been released in many parts of the country, and in some places, such as islands in Puget Sound, they have become numerous and destructive. The snowshoe hare is also called a varying hare because it turns white in the winter to match the snow and brown in the summer to match the vegetation; so does the arctic hare.

Hares are cyclic, in that they go through a population boom and bust every nine years. The timing of this cycle varies in different parts of the country. A call to your state fish and game department will let you know if it's a good year to concentrate on hares. Hares are not as accustomed to people as are rabbits, so you have to work at longer

200–400mm zoom lens with 1.4 teleconverter, Kodachrome 64 film, 1/125 sec., f/4. By late May, the snowshoe hare has changed back into its brown summer coat to match the vegetation. LEONARD LEE RUE III

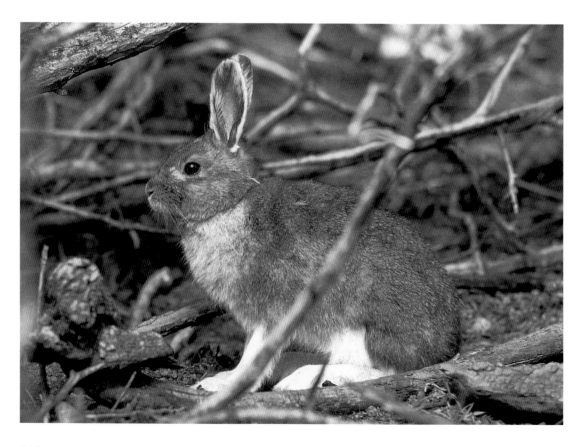

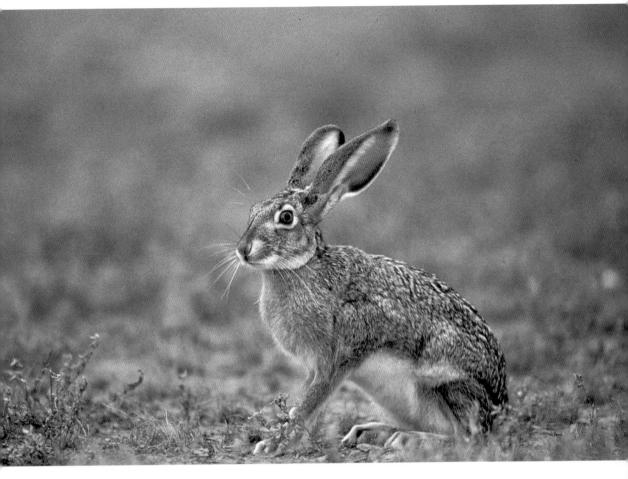

200–400mm zoom lens with 1.4 teleconverter, Kodachrome 64 film, 1/125 sec., f/4. The exceedingly large ears of the black-tailed jackrabbit help disperse the animal's body heat. LEN RUE, JR.

distances. I found that by moving very slowly, I could get within 25 feet of the snowshoes as they fed in Denali National Park.

There are three jackrabbits, and all are western animals. The white-tailed jackrabbit is found at higher elevations and is white in the winter and brown in the summer. The black-tailed jackrabbit is found in the high and low plains areas of the western states. These jackrabbits, like the hares, are cyclic. The antelope jackrabbit is slightly larger than the other two and has huge ears that act as thermoregulators. It is found in the deserts of the Southwest.

Porcupines. Most porcupines are black with light tips on their guard hairs, but some of the western and southern porcupines are yellow in coloration. Porcupines are usually solitary. They are not easy to photograph because they are very determined animals. When they decide to go somewhere, they just go. Using great caution, I have held one down with my foot while I stroked its tail quills. I have picked one up and started it up a small sapling so that I could photograph it.

111

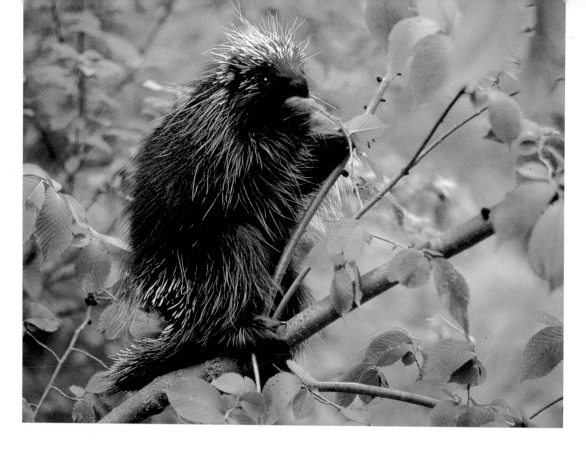

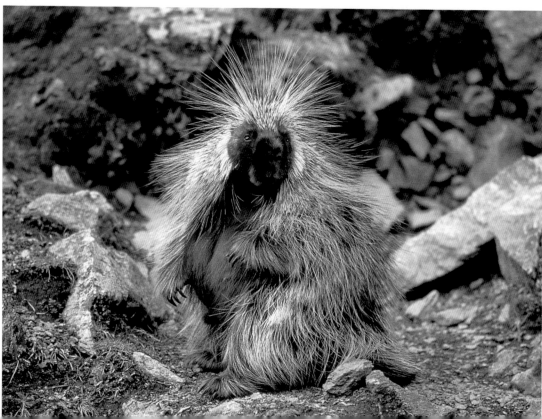

80–200mm zoom lens, Kodachrome 64 film, 1/125 sec., f/5.6.
The porcupine in its black phase can be found in most of North America, except the Southeast and the West Coast. USCHI

200–400mm zoom lens with 1.4 teleconverter, Kodachrome 64 film, 1/125 sec., f/6.3.
The porcupine in its yellow phase is found only in northwestern North America. USCHI

They will flail out with their tails, trying to slap their quills into your flesh, but they cannot throw their quills.

Armadillos. The armadillo is found in Texas, Oklahoma, Kansas, Arkansas, Louisiana, Mississippi, Alabama, Georgia, and Florida. It is a holdover from the armor-plated animals of thousands of years ago. It feeds primarily on insects and is absolutely harmless to humans. It has only a few rudimentary grinding teeth in the back of its

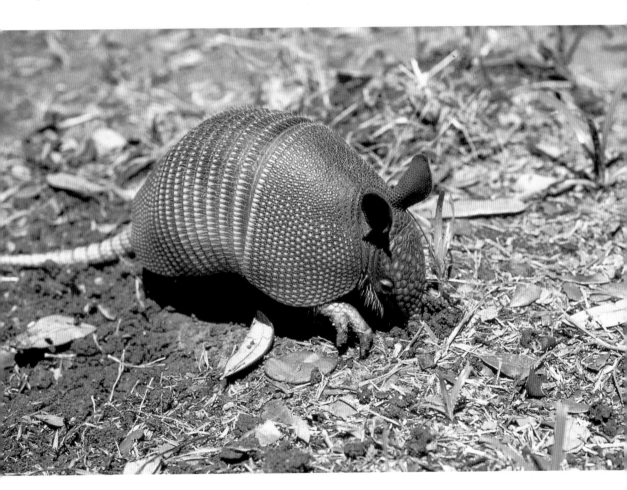

80–200mm zoom lens, Kodachrome 64 film, 1/250 sec., f/8.
Armadillos are quite common in the southern United States, where they feed mainly on ants.
LEONARD LEE RUE III

mouth. Armadillos evidently find their insect prey by scent, yet I had one walk between my outstretched legs. I simply reached down and picked it up by both sides of its shell.

The armadillo may feed at night, but I have found them out at all times of the day; they are least active for a couple of hours around noon. When driving through the states mentioned above, you often see them feeding on the mowed highway rights-of-way. Don't stop near them; pull up the road a couple hundred feet and then, with your biggest lens on your camera, walk back and shoot. If an armadillo gets suspicious, it often stands up on its hind feet to get a better look at what disturbed it, but its eyesight isn't very good. When alarmed, they dash off for the safety of a burrow or some dense vegetation. They don't run all that fast, but most of the vegetation they run under is armed with thorns, and you can't follow them.

Peccaries. The collared peccary, or javelina, as it is called in Spanish, is a little wild pig that is commonly found in the southwestern states. They are very gregarious and travel in herds of 10 to 50. Their tusks are about $1^{1}/_{8}$ inches long and are fearsome weapons, although I have never seen them show aggression toward people. The white-lipped peccary of Central America is a much more aggressive animal, and I think that's where stories of the peccary's ferociousness originated.

I first photographed peccaries at the famous waterhole at the Sonora Desert Museum near Tucson. Since then, I have photographed them in many Texas parks and refuges. Aransas National Wildlife Refuge has a large population of them. The simplest way to photograph a peccary is to drive the roads in these areas and, using

200–400mm zoom lens with 1.4 teleconverter, Kodachrome 64 film, 1/250 sec., f/5.6.
The only native North American member of the pig family, the collared peccary (or javelina) is common in the southwestern United States. LEN RUE, JR.

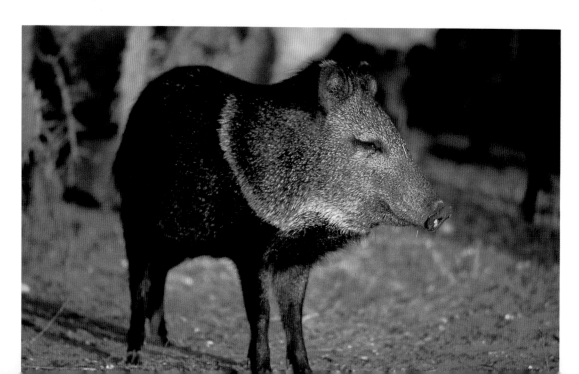

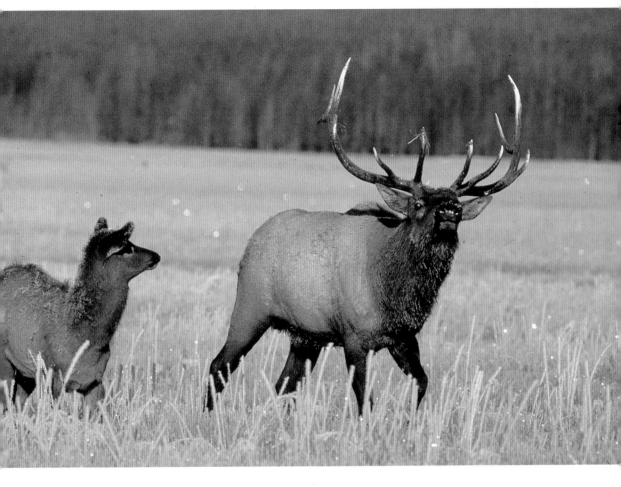

200–400mm zoom lens with 1.4 teleconverter, Kodachrome 64 film, 1/250 sec., f/8.
A frosty morning transformed Yellowstone National Park into a glittering fairyland, a spectacular setting for this bull elk and calf. LEN RUE, JR.

your Groofwin, shoot from your car window. If you plan to get out, stop at least 200 feet away from where they are feeding and slowly walk within camera range.

Elk. Elk are probably the easiest of all big-game animals to photograph. Their comeback has been so successful that they can be found in most western national parks and refuges.

The Tule elk can be photographed in its refuge outside Bakersfield, California. The big Roosevelt elk is most easily photographed in Washington's Olympic National Park. Jasper and Banff National Parks in Canada, Yellowstone and Grand Teton National Parks in Wyoming, and Rocky Mountain National Park in Colorado are all excellent places to photograph the Rocky Mountain elk. The National Elk Refuge near Jackson Hole, Wyoming, holds the largest concentration of wintering elk in the world, up to 10,000 animals. Unfortu-

115

nately, at Jackson Hole you have to go out with a tour group; all the other spots can be worked by individuals.

Probably 80 percent of all the elk photographs sold are taken in Yellowstone National Park. It is simply a matter of being in the park the last three weeks in September and the first two in October. You can also pray for an early snow to push the elk down from the high mountain meadows, where they spend the summer.

I believe in getting out while it is still dark so that I can be among the first to photograph elk activity. I can't imagine anyone who wants to be a wildlife photographer grousing about getting up early in the morning. The greatest amount of wildlife activity usually takes place at dawn and dusk. When photographing elk and moose, use no lens shorter than a 400mm, preferably with a 1.4 teleconverter.

Moose. Alaska and the Yukon have the largest moose in the world. Denali National Park has a large moose population, as does the moose sanctuary on the Kenai Penin-

sula. Prior to the hunting season, the moose can be photographed in most ponds and lakes along most highways. In winters with deep snow, the moose can be photographed right in the cities of Anchorage and Fairbanks.

Probably the best place to photograph moose in the east is up in Maine. The moose has made such a comeback there that they are dispersing to the other New England states and New York's Adirondack Mountains. The many lakes around Baxter State Park in Maine are favored by moose photographers.

The Shiras moose is the smallest moose, but the size of a big bull is still impressive. Some of the most famous spots for pho-

200–400mm zoom lens with 1.4 teleconverter, Kodachrome 64 film, 1/250 sec., f/6.3.
Alaska and the Yukon are home to the largest bull moose in the world. This bull's antlers have a spread of over six feet. LEN RUE, JR.

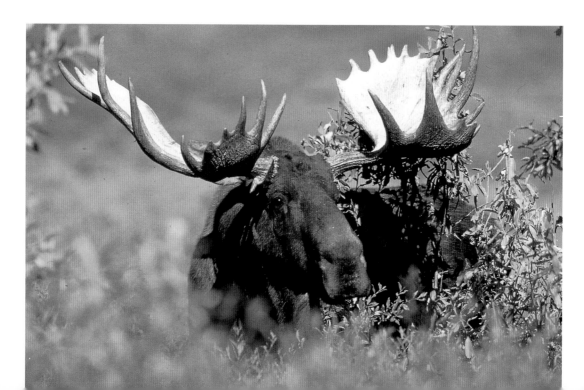

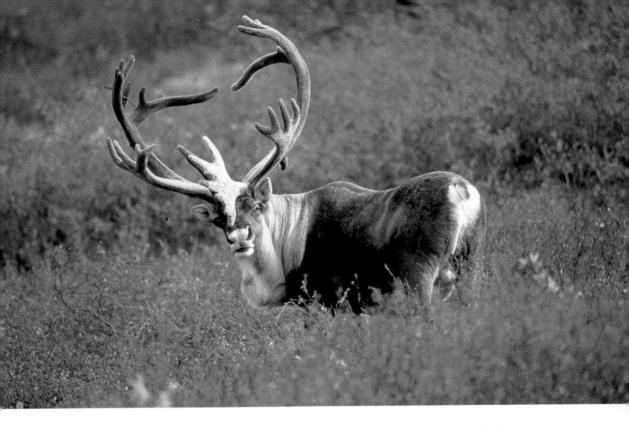

200–400mm zoom lens with 1.4 teleconverter, Kodachrome 64 film, 1/250 sec., f/5.6. This huge Barren Ground caribou, photographed in Denali National Park, sports a record-book set of antlers. LEN RUE, JR.

tographing Shiras moose are the Pelican Creek, Willow Park, and Lewis Falls areas in Yellowstone and all through the Grand Teton area down into Jackson.

Because moose feed heavily on water plants, it is comparatively easy to spot them in lakes and ponds. All summer long they seek relief from the hordes of biting flies and mosquitoes by feeding in the deep water. The big bulls can be exceedingly aggressive during the rutting season in the month of September, and the cow moose is even more so during June, July, and August, when her calves are young.

Caribou. There are very few spots in North America where you can actually drive to photograph caribou. The most famous is Denali National Park in Alaska. Unfortunately, there have been no big migrations in

that park for 30 years. The largest herd I ever saw had about 400 animals, and that was back in 1966. In 1993, however, I saw more caribou in the park than I had seen in all the intervening years, with one herd numbering over a hundred. Another spot is the haul road going to the town of Deadhorse on Prudhoe Bay, Alaska. If you catch the major part of a migration, you can see thousands of caribou in one passing.

If you live in the eastern part of North America, I suggest that you try for caribou up on Quebec's Ungava Peninsula. Although you can't drive there, you can fly there less expensively than you can fly to Alaska. Sign up with one of the outfitters in the area to take you out. The caribou herd in Ungava has grown so large that the Quebec government had to increase the number of caribou

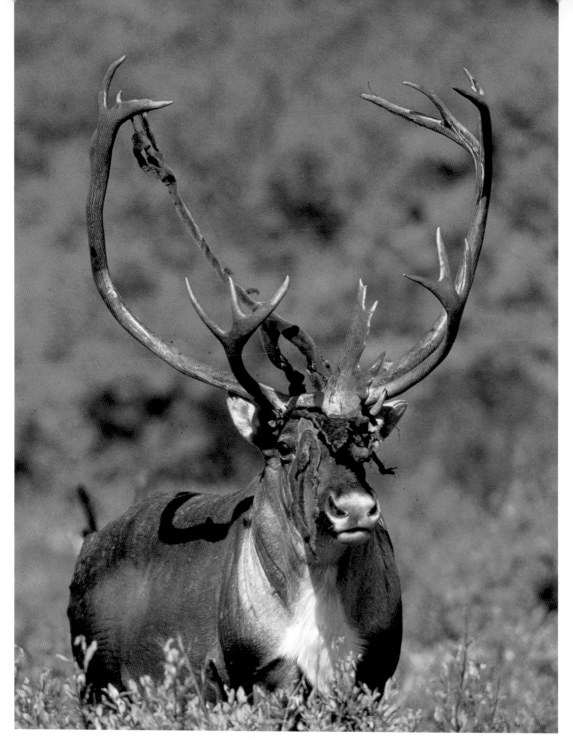

200–400mm zoom lens with 1.4 teleconverter, Kodachrome 64 film, 1/250 sec., f/6.3.
All antlered animals, like this caribou, shed their velvet (the blood vessels that nourish the
antlers' growth) in late August or early September. LEN RUE, JR.

harvested to prevent the destruction of habitat.

Caribou are unpredictable animals. In Denali, I stopped my car a quarter of a mile away from a caribou and had it run off. Then the same caribou turned around and trotted right back to be photographed with a 55mm lens. At the Eielson visitors' center in the park, the caribou walk right in between the tourists, and I've gotten down on my knees to photograph their huge feet.

Deer. The recovery of the white-tailed deer population, from a low of around 500,000 in the late 1800s to the present population of 21 million, is one of this continent's greatest success stories. I am willing to bet that no person in the eastern half of the United States lives more than 25 miles from these deer. Deer are exceedingly adaptable and can be found in suburban and urban areas as well as out in the country. The deer thrive in city parks, on the

200–400mm zoom lens with 1.4 teleconverter, Kodachrome 64 film, 1/125 sec., f/4. Like all good mothers, white-tailed does constantly groom their fawns. LEN RUE, JR.

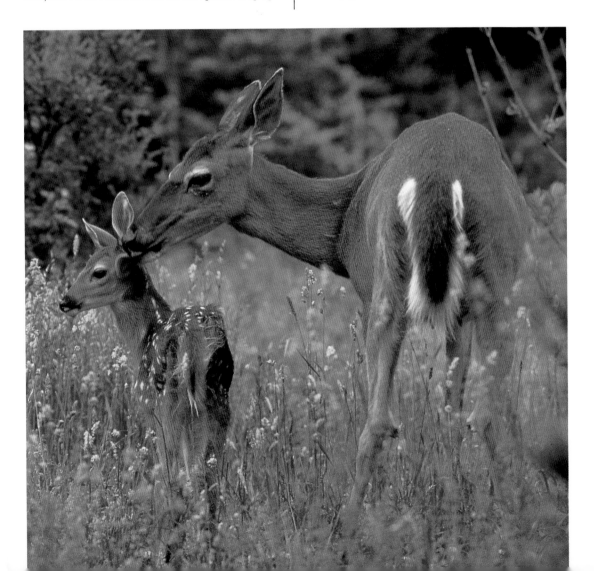

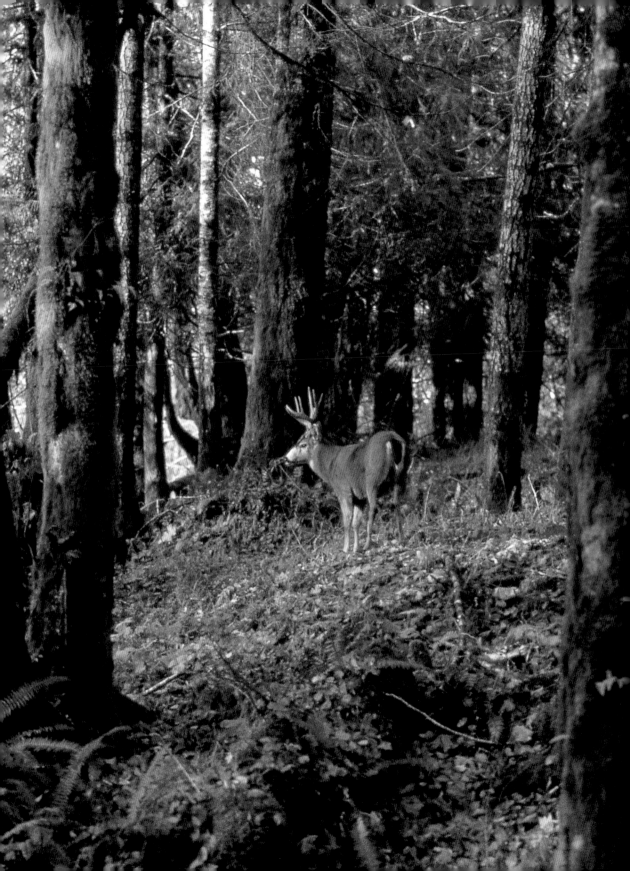

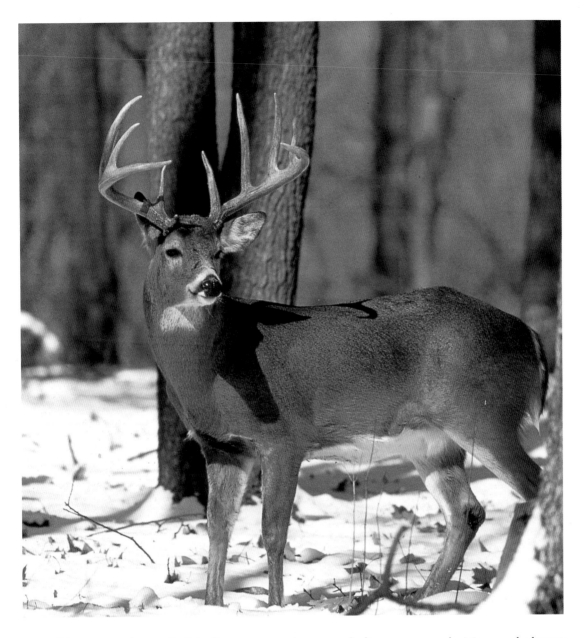

200–400mm zoom lens with 1.4 teleconverter, Kodachrome 64 film, 1/250 sec., f/8 (above). This picture-perfect white-tailed buck is definitely a calendar candidate. LEN RUE, JR.

500mm Hasselblad lens, Ektachrome X film, 1/30 sec., f/8 (opposite page). The dark forest of Olympic National Park in Washington is home to this black-tailed buck. LEE RUE, JR.

green beltways around cities, and almost everywhere except in the concrete canyons in the heart of the biggest cities. Whitetails are plentiful in most of the western states as well, with Texas having about four million. California and Nevada have very few, if any, whitetails.

Mule deer are harder to photograph, as they are restricted to the western third of the continent, and their population has

decreased to about four million. In places such as Yellowstone, where the elk population has exploded, the mule deer population has been decimated. The best spot to photograph big mule deer bucks is Waterton-Glacier International Peace Park. There are some monster bucks there.

The black-tailed deer is actually a subspecies of the mule deer. Blacktails are found along the coast of California and north to southeastern Alaska. They inhabit the lush rain forests of Alaska, British Columbia, and Washington and the dry brush country of California. They frequent areas of dense vegetation, are usually quite wary, and can slip away at will. The best place to photograph black-tailed deer is in Olympic National Park.

With all types of deer, lenses in the 400–500mm range, plus teleconverters, are needed. A lot of your work will have to be done from blinds.

500mm Hasselblad lens, Ektachrome X film, 1/250 sec., f/9.
Pronghorn antelope are found wherever there's sagebrush. LEN RUE, JR.

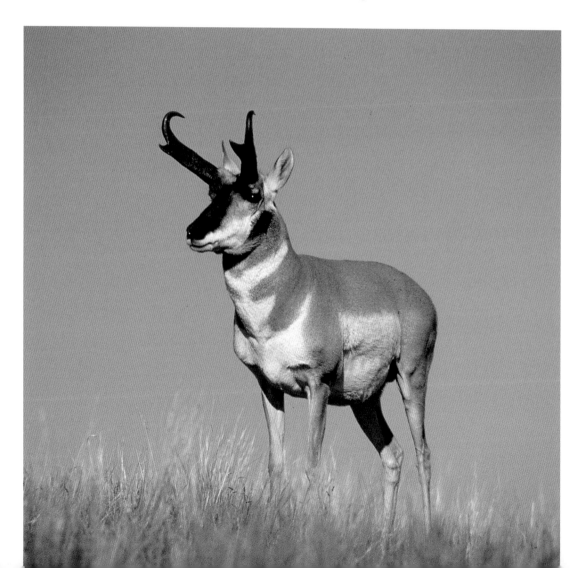

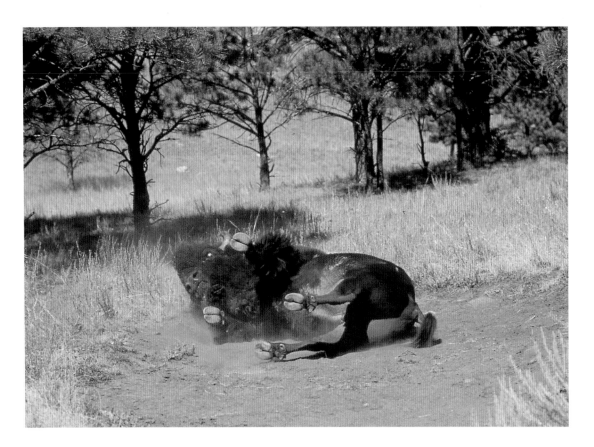

Pronghorn Antelope. The pronghorn is the fastest running animal in North America, capable of hitting speeds of up to 60 mph. You can find pronghorn almost anywhere that you find sagebrush—from western Nebraska to eastern Oregon. Central Wyoming, around the town of Lander, has more antelope than anywhere else. If you're driving through in the evening and you don't see 500 to 700 animals in a couple of hours, you're just not looking.

The National Bison Range and the Charlie Russell Refuge in Montana, Custer State Park in South Dakota, Hart Mountain Refuge in Oregon, and Yellowstone National Park are all great places to photograph pronghorn. Your best chance of success outside of parks and refuges is to place one of our Ultimate Blinds near a water hole. The pronghorn live in dry prairie country, but they come in to drink once or twice a day.

500mm Hasselblad lens, Ektachrome X film, 1/250 sec., f/9.
This bison bull rolls in the dust to get relief from the biting parasites that make their home in his dense coat. LEONARD LEE RUE III

Bison. You will undoubtedly see more bison in Yellowstone than anywhere else, but there are large herds scattered all across the western states. Wichita Mountains in Oklahoma, Custer State Park in South Dakota, and the National Bison Range in Montana are just a few of the many spots I have photographed them. The two peak times of activity are in late May when the russet-red calves are born and again in August and September when the breeding season occurs. When photographing bison, give them space; they are big, strong, fast, and unpredictable. They can run at speeds of 30 miles per hour. A cow is just as likely to

charge as a bull. On average, 15 people are gored by bison in Yellowstone each year.

Musk Oxen. With the exception of the haul road going to Alaska's Prudhoe Bay, I know of no other place in the world that you can drive to see musk oxen. Then, seeing them is the easy part; the hard part is the miles of walking you may have to do to catch up to them. Thankfully, the tundra north of the Brooks Range is usually dry, but walking on any kind of tundra is hard work.

Probably the easiest place to photograph musk oxen is on Nunivak Island off Alaska's west coast. There are usually 800 or more of the animals there, and Nunivak musk oxen are used to restock the rest of Alaska. But it is expensive to get to Nunivak, because it can be reached only by air or boat.

Although most musk oxen will run when approached, occasionally a big bull may be aggressive and charge. There are no trees to climb in musk ox land; use your longest lens.

Mountain Goats. The hardest work I ever did in wildlife photography was trying to photograph goats on top of the mountain right outside the town of Haines, Alaska. I also worked hard to get them on Harney's Peak in South Dakota, up in Waterton National Park in Canada, and on top of Mount Evans in Colorado. It's not just the physical effort; it's the elevation. Mount Evans is up around 15,000 feet. The easiest way to photograph them is to drive to the

200–400mm zoom lens with 1.4 teleconverter, Kodachrome 64 film, 1/125 sec., f/5.6. A group of musk oxen will form a united front when faced with danger. LEONARD LEE RUE III

*200–400mm zoom lens with 1.4 teleconverter, Kodachrome 64 film, 1/250 sec., f/6.3.
Although I've taken many photographs of mountain goats, this remains my favorite because the
goat is skylined and shown in its typical habitat.* LEONARD LEE RUE III

top of Going-to-the-Sun Highway in Glacier National Park and take the path behind the visitors' center to Hidden Lake. The goats often use the same path.

Wild Sheep. The hardest of the four types of sheep to photograph are Stone's sheep, a subspecies of Dall's sheep. They are found in the Yukon and British Columbia. Some of them come down to the Alcan Highway to get minerals, but I never saw a decent ram there. Where the sheep are protected, they become very trusting. Where they are hunted, they become one of the wariest of all wild animals.

Most Dall's sheep pictures are taken in Denali National Park. But the park was buried in a very deep, very early snowfall in September 1992 that created a tremendous hardship on all the wildlife. In 1993, I couldn't find a big ram anywhere.

Bighorn sheep are much more common and can be photographed in many places, including near the Columbia Glacier, halfway between Jasper and Banff in Canada. They can be photographed in the National Bison Range and Glacier National Park in Montana, and in Yellowstone and Whiskey Basin in Wyoming, as well as in other spots.

The desert bighorn sheep is almost as hard to photograph as the Stone's. Most of the photos of these sheep that you see were taken at the Desert Bighorn Sheep Refuge located north of Las Vegas. The Kofa

125

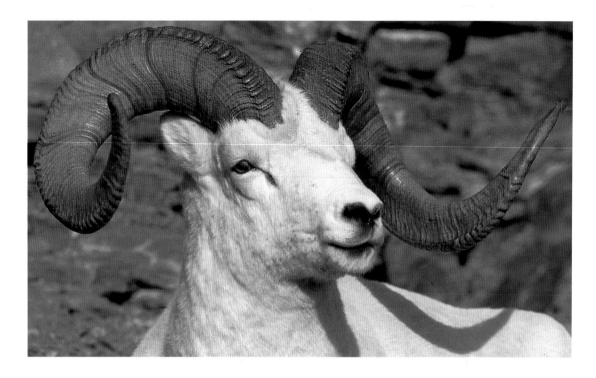

200–400mm zoom lens with 1.4 teleconverter, Kodachrome 64 film, 1/250 sec., f/8.
Of all the sheep I've photographed, this Dall's ram has the most magnificent set of horns I have
ever seen. LEONARD LEE RUE III

National Wildlife Refuge near Yuma, Arizona, is also a good spot for these sheep. But don't go to Kofa in the summer, when the temperature often soars above 110 degrees. The key to survival in these refuges is water, and the key to photographing sheep is to catch them when they come to drink. Many photographers do it the easy way by photographing these sheep at the Sonora Desert Museum near Tucson.

Manatees. I have always wanted to photograph a manatee, and I have the Nikonos equipment needed to do the job. I just have never gotten around to actually doing it. There are a number of spots in Florida where the manatees can be seen and photographed. Chascahowitzka National Wildlife Refuge near Crystal Springs and Homosassa Springs State Park are two of the best spots to view and photograph these gentle creatures.

Tips on Wildlife Photography
Leonard Lee Rue III

Following are 10 basic tips that should be remembered when taking photographs of any type of wildlife.

1. Whenever possible, shoot at the animal's own eye level or from a lower angle. This provides an intimacy that you do not get if you stand above it and shoot down. This means that you will frequently be kneeling, and occasionally lying down, to take your photos. For this purpose, I often use padded knee and elbow guards designed for athletes.

200–400mm zoom lens with 1.4 teleconverter, Kodachrome 64 film, 1/250 sec., f/8. Skylining an animal often shows it off to its best advantage. LEONARD LEE RUE III

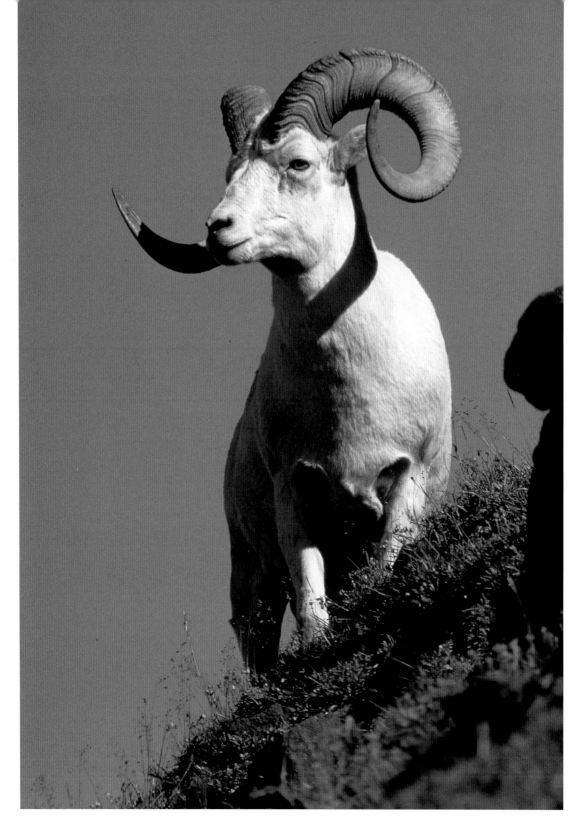

2. Get in the habit of focusing on your subject's eyes, because the eyes are always the primary focal plane. Unless you deliberately look somewhere else, you—and everyone else—will automatically look at the eyes first. If the eyes are sharp, most people will not even notice if other parts are out of focus, and they won't care.

3. Nothing breathes life into a photograph more than having a highlight in the subject's eyes. Some predatory animals, and many birds, have such deep-set eyes that this is almost impossible. The eyes of almost all the prey species, however, protrude so far from the skull that this is seldom a problem, as long as the light is behind you.

4. Unless you are trying for some special effect, such as a silhouette, try to have the sun somewhere behind you or at no more than 90 degrees off your shoulder.

5. Whenever possible, try to "skyline" an animal. Photographs of an animal standing

200–400mm zoom lens, Kodachrome 64 film, 1/125 sec., f/4.5
Nature does its best to camouflage the snowshoe hare; it's the photographer's task to make it visible. USCHI

on the top of a hill against a bright blue sky have tremendous impact. You don't get the same effect when the sky is overcast. Scattered clouds are okay, but the best results are produced against a clear sky.

6. Use overcast weather conditions to your advantage. You can photograph an animal from almost any direction on an overcast day, and that's a tremendous plus; it means that you don't have to move around as much to get the light in a favorable position. An overcast day also allows you to photograph in a dark forest—something you can't do on sunny days without a flash.

7. Try to avoid including several animals in your photograph. It's hard enough to get one animal in sharp focus, and unless all the animals are on the same plane, some will be out of focus. If the light is good, your film is fast, and the wildlife is standing still—it usually isn't—you can shoot at a slower shutter speed and a higher f-stop to increase your depth of field. When you are going to have more than one animal in your photograph, focus on the one that is nearest to you. This will give you the greatest chance of having more or all of the animals in sharp focus.

8. Use the longest telephoto lens you have to make animals stand out from their surroundings. Most animals are colored in neutral tones for two basic reasons. First, most animals, with the exception of primates, do not see color except in the colder, ultraviolet range. Second, most animals are designed to blend into their surroundings. One of the hardest jobs for a photographer is to separate an animal from its surroundings; they are designed to blend in, and we have to make them stand out. The longer telephoto lens's inherently shallow depth of field often subdues the background or even eliminates it, thus helping to make the animal stand out.

9. When photographing smaller animals that you can get closer to, use the longest lens that still allows you to fill the frame satisfactorily. Do not use shorter lenses and get closer to the subject, because you will create a reflection of yourself in the animal's eye. To avoid this, I use a 200mm macro lens instead of a 55mm lens.

10. Use a longer lens to prevent distortion. Portrait photographers prefer using a 135mm lens rather than a 50mm lens because it does not distort the person's features; it puts them in the proper perspective. To show an animal exactly as it is, use a longer lens for the same reason.

Good luck and good shooting.

RESOURCES

Books

Angel, Heather. *Photographing the Natural World.* Sterling, 1994.

Brandenburg, Jim. *Brother Wolf.* North Word, 1994.

Campbell, Laurie. *The Royal Society for the Protection of Birds' Guide to Bird and Nature Photography.* David & Charles, 1990.

Guravich, Dan, and Downs Matthews. *Polar Bear.* Chronicle Books, 1993.

Herrero, Stephen. *Bear Attacks: Their Causes and Avoidance.* Lyons & Burford, 1985.

Hill, Martha, and Art Wolfe. *The Art of Photographing Nature.* Crown, 1993.

Lepp, George. *Beyond the Basics.* Lepp & Associates, 1993.

McDonald, Joe. *The Complete Guide to Wildlife Photography.* Amphoto, 1992.

———. *Designing Wildlife Photographs.* Amphoto, 1994.

National Parks Foundation. *Complete Guide to America's National Parks.* Prentice-Hall, 1991.

Norton, Boyd. *The Art of Outdoor Photography.* Voyageur Press, 1993.

O'Brien, Tim. *Where the Animals Are.* Globe Pequot, 1992.

Ozaga, John. *Whitetail Autumn.* Willow Creek Press, 1994.

Petersen, Moose. *Nikon Guide to Wildlife Photography.* Silver Pixel Press, 1993.

Peterson, Bryan. *Understanding Exposure.* Amphoto, 1990.

Regendes, Paul. *Tracking and the Art of Seeing.* Camden House Publishing, 1992.

Riley, Laura, and William. *Guide to the National Wildlife Refuges.* Macmillan Publishing Co., 1992.

Rue, Leonard Lee III. *Cottontail Rabbit.* Thomas Crowell, 1965.

———. *The Deer of North America.* Times Mirror, 1978.

———. *Furbearers.* Crown Publishers, 1981.

———. *How I Photograph Wildlife and Nature.* W. W. Norton, 1984.

———. *Pictorial Guide to the Mammals of North America.* Thomas Crowell, 1967.

———. *Whitetails.* Stackpole Books, 1991.

———. *Wolves.* Magna Books, 1993.

———. *The World of the Raccoon.* Wild Ones Animal Books, 1994.

———. *The World of the White-tailed Deer.* J. B. Lippincott, 1962.

Schaub, George. *The Amphoto Book of Film.* Amphoto, 1993.

Shaw, John. *The Nature Photographer's Guide to Complete Field Techniques.* Amphoto, 1984.

Stroebel, Leslie, and Hollis Todd. *Dictionary of Contemporary Photography.* Morgan & Morgan, 1974.

Watchable Wildlife Series. Morgan & Morgan, 1974.

Wildlife Rental Farms

Dan and Pam Bacon, Skip Kaplan
Red Feather Lakes
20490 West County Road 74 East
Red Feather Lakes, CO 80545
800-488-4244

Jay Diest
Triple D Game Farm
P.O. Box 5072
190 Drake Drive
Kalispell, MT 59903
406-752-2189

Equipment and Clothing

Carry-Lite Decoys
5203 West Clinton Avenue
Milwaukee, WI 53223
414-355-3520

Feather Flex Decoys
1655 Swan Lake Road
Bossier City, LA 71111
318-746-8596

Flanders Products Corporation
15981 Valplast Road
Middlefield, OH 44062
216-632-1631

Icebreaker, Inc.
5 Jefferson Street
Clarksville, GA 30523
706-754-3732

LaCrosse Footwear, Inc.
P.O. Box 1328
LaCrosse, WI 54602
800-323-2668

Scents, Baits and Calls
Charley Burleson
Helping Hunters
R.D. Box 39
Great Valley, NY 14741
716-945-4521

Trebark-Bowing Enterprises
3434 Buck Mountain Road
Roanoke, VA 24014
707-774-9248

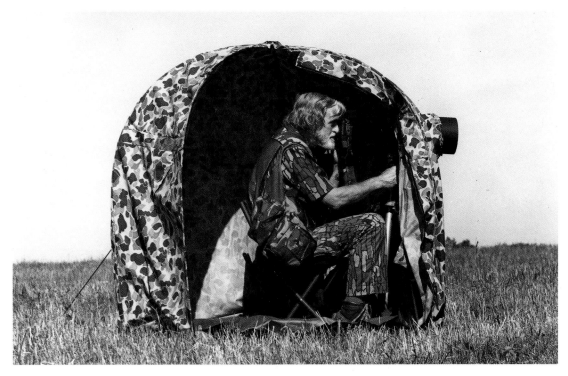

L. L. Rue III using the Ultimate Blind. MARK WILSON

L. L. Rue Catalog Available

Our catalog features a selection of the finest photographic and outdoor equipment, accessories, books, and videos available. Of special interest are the Rue Ultimate Blind, which can be completely set up and ready to use in 30 seconds; the Groofwin Pod, which allows you to photograph from your vehicle window with tripod stability; and the Rue professional photo vest. Other items include camera packs, tripods, tripod heads, protective wraps, lens cases, photographers' gloves, camera mounts, shoulder stocks, and many other useful and unique accessories. Our carefully selected line of nature, outdoor, and photographic books includes many written by Dr. Rue: *How I Photograph Wildlife & Nature, The Deer of North America, The World of the Raccoon, Birds of Prey, Elephants,* and *Alligators and Crocodiles,* among others.

Videos by Dr. Rue include *Basics of Bird Photography, Advanced Bird Photography, Rutting Whitetails,* and *An Eye on Nature.* For your free copy of our catalog, please contact Leonard Rue Enterprises, 138 Millbrook Road, Blairstown, NJ 07825. Telephone: 908-362-6616. Fax: 908-362-5808.